PAINTING LANDSCAPES IN OILS

PAINTING LANDSCAPES IN OILS

Norman Battershill

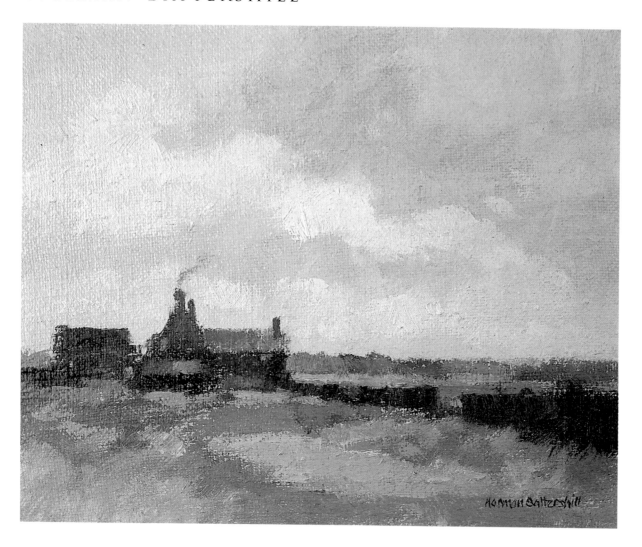

B T Batsford Ltd, London

First published in 1997 by
B T Batsford Ltd
583 Fulham Road
London SW6 5BY

A catalogue record for this book is
available from the British Library.

ISBN 0 7134 7742 3

Printed in Singapore

Contents

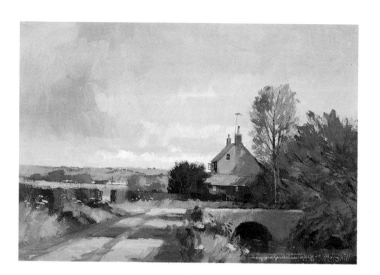

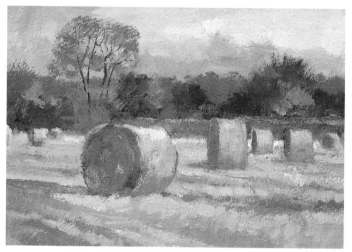

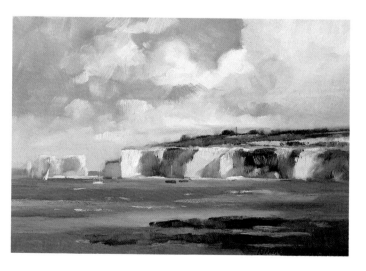

Acknowledgements

In anticipation of their kind approval, I wish to thank collectors of my paintings for permission to reproduce some of the work in this book.

My thanks also go to Susan Vince, at Kings Secretarial Services, for her dependable service and ability to decipher my longhand.

Michael McEnnerney L.B.I.P.P., for photographing some of the paintings, ProFoLab, C G Giles BA (Econ) L.R.P.S. and John Morley L.M.P.A., L.B.I.P.P.

Abigail Glover, Commissioning Editor at Batsford, London, and the staff who put the book together.

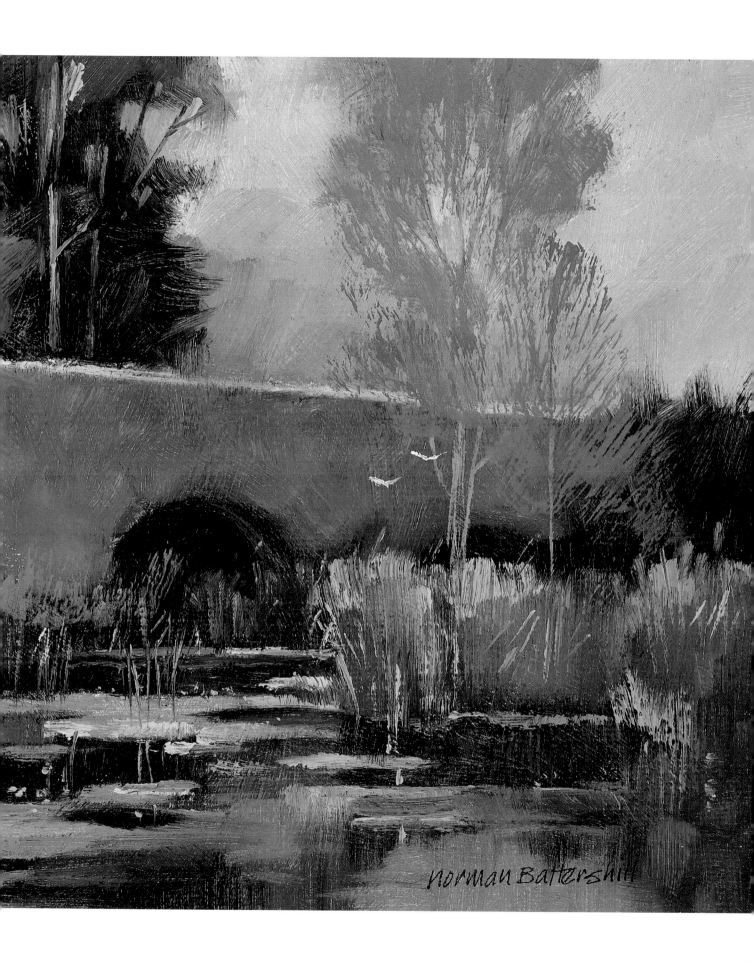

Introduction

'An accurate record of a scene, although it may be true to the facts, will not charm, will not move us so much as a picture where the effect, or sentiment, of atmosphere or light is the dominating motive.'

George Clausen A.R.A.R.W.S.
Professor of Painting at the Royal Academy 1904

The pleasure of landscape painting lies in the infinite variety of subjects and the ever-changing moods and atmosphere of light and weather. Capturing the spirit of the open air and creating a sense of aerial space within the confines of a picture frame is an exciting challenge.

My apprenticeship to landscape painting began long ago in the rich green fields of Sussex. Every day on the way through the lanes to my studio I would stop to paint or draw, whatever the weather. Looking back at those early paintings, I do not see any outstanding merit but they do show a sincere endeavour to understand the landscape. It was the beginning of a happy and ongoing relationship with Nature and a close involvement with her moods and secrets.

Over the years, I produced a steady flow of sketches and paintings, and eventually my dedication began to be rewarded with some degree of success. Today, thirty years or so later, I still continue my lessons direct from Nature. The pleasure has not diminished in the slightest and I know I shall never cease to learn something new every time I paint or draw outdoors.

This book is based on my experience of learning how to paint landscapes. There are no shortcuts to success but here you may find a useful source of reference and guidance.

Norman Battershill

Norman Battershill

Successful Landscape Painting

All forms of learning require structure if success is to be achieved. The landscape can be a complex subject with aspects that require individual study. Therefore this book is divided into sections focusing on the essentials of landscape painting. As well as being a concentrated study, it forms a convenient and easy reference to each of the principal elements including skies, water, trees, buildings and coastlines.

Before starting to paint you will need some basic equipment. This is covered in detail in Chapter One. The second chapter illustrates the use of aerial perspective and explains which colours to mix to achieve an illusion of space and recession.

Perhaps the most neglected part of landscape painting is the sky. Capturing nature's moods requires an intimate knowledge of the way light from the sky affects the landscape. Cloud types and aerial perspective are featured in Chapter Three.

Another often neglected landscape feature is water. An aspect of water in a painting will always add further interest whether it is just a puddle or a flowing stream. Chapter Four illustrates how to paint still and moving water and simplifies the problems of reflections.

Trees are an integral part of the landscape but are so often rendered with indifference. Methods of studying them and their importance in composition are discussed in Chapter Five.

Drawing and painting buildings and structures convincingly requires some knowledge of perspective. By following a few basic principles, as shown in Chapter Six, determining angles of perspective need not present a problem.

Chapter Seven features coastline subjects which offer a wide range of possibilities, while Chapter Eight illustrates methods of interpreting and expressing nature's moods in studio landscapes.

Painting in the studio has the advantage of allowing you to give much greater consideration to your picture. Developing a sketch into a painting in the studio is covered in Chapter Nine.

Learning how to paint the landscape well is achieved through a combination of technical ability, an intimate understanding of the many aspects of nature and a desire to express your response to the subject. Landscape painting is complex and exciting but with practice and patience success is within reach of everyone.

CHAPTER ONE

Materials and Equipment

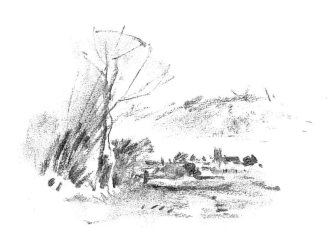

PAINTING SUPPORTS AND PRIMING

CANVAS

Linen or cotton canvas is the traditional support for oil painting. Commercially prepared canvas panels are readily available in standard sizes. Paper with an imitation canvas texture is available in blocks or pads and makes a cheap commercially prepared support for oils. To avoid possible damage to the surface of a painting it is preferable to mount the paper to board prior to painting rather than afterwards. Primed cotton canvas sold in pads, blocks or separate sheets is another economical buy. Ready-stretched canvas in standard sizes and a variety of textures is popular with many artists who prefer a resilient surface to paint on. Whichever your preference, use artists' quality materials as they are worth the extra cost.

PAPER

The cheapest oil painting supports are paper and card. If some degree of durability is desired both should be acid free and sealed with an acrylic primer or acrylic medium.

Watercolour papers suitably primed can be used for oil painting. Try the delightful texture of Bockingford and other watercolour papers. A quantity of paper for oil painting is much lighter to carry when painting outdoors than the equivalent number of boards.

HARDBOARD AND MDF

To prepare these supports for painting, lightly rub the surface (I do not recommend the rough side of hardboard) with medium glass paper. I mix the dust left on the surface into the acrylic gesso primer as I brush it on. The fine particles create a textured surface which has a slight 'tooth' when dry and becomes sealed in the primer. Additives to priming that give a textured surface must be used with discretion. Pronounced texture may be detrimental to the appearance of a painting particularly if it is small. Experiment to determine the amount required to produce a suitable texture.

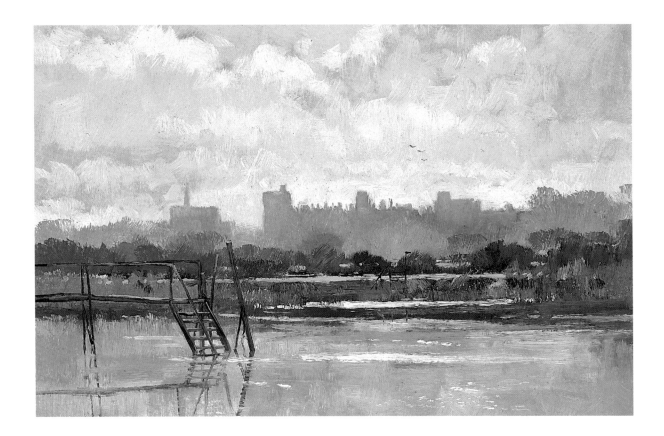

There are a number of acrylic-based texture pastes and additives on the market which are suitable to mix with acrylic priming for oil painting.

OIL PAINTS

There are two qualities of oil paints. The first, student quality paint, contains less pigment and more binder than the second, artist quality, but for the beginner it is an economical way of learning about the medium. Artist quality oil colours are more refined, with a greater intensity and richness of colour.

Although I have a variety of artist oil colours in my paintbox, I usually begin a painting with only four – cadmium red, yellow ochre, burnt sienna and ultramarine – along with white. To these I may add cadmium yellow pale, viridian and cadmium orange.

To vary colour schemes I change the primaries, using for example cobalt blue instead of ultramarine, or alizarin crimson instead of cadmium red. Experimenting with different colour combinations can produce some pleasant and wide-ranging effects.

ARUNDEL CASTLE, 46 x 35.5cm (18 x 14in)

OIL PAINTING MEDIUM

A popular home-made medium to improve the flow of oil paint is one part linseed stand oil diluted by one part turpentine. It softens brushmarks and increases gloss but dries slowly.

Proprietary brands of painting media are fully described in manufacturers' catalogues or their free information booklets. I rarely use a medium but when it is necessary to hasten the drying time, I use Winsor & Newton Liquin, Wingel or Olepasto. Both the latter retain brushmarks.

BRUSHES

A good brush does not necessarily make a good painter, but choosing quality brushes is the right way to begin. The choice of brushes available is a bit daunting but you only need to start with a few.

Artists' hog-hair brushes are superior and are available in a presentation set supplied by leading manufacturers, which forms an economical way of purchase. My personal choice is

the long flat brush, which has excellent paint-carrying capacity and flexibility. Short flats (brights) and long bristle brushes (filberts) with rounded ends are also the main types for oil painting. A couple of synthetic riggers for linear work completes the selection of brushes you need.

Although I have a large number of various brushes, the few I use the most are long hog flats Nos. 10, 8, 6, 4 and 2 plus a synthetic rigger size No. 1, and also a 5cm (2in) decorator's varnishing brush.

EASELS

An easel is very important and you should give it careful consideration before buying. Choose the best you can afford.

For painting outdoors an easel must be compact, lightweight, easy to erect and secure with the minimum of simple fixings. The lightweight traditional wooden sketching easel is the most popular. If the legs have rubber ferrules, the easel can be used indoors without damaging the floor covering, or if spiked you can fix corks. Although expensive, the sturdy radial easel is ideal and makes an excellent investment. The tripod base takes up very little floor space so it can stand out of the way in a corner while not in use. Most radials will support a 1880mm (74in) canvas. The

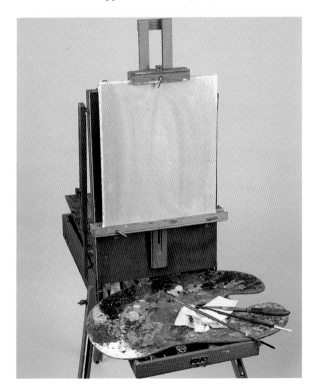

smallest and most convenient indoor easel is the table-top easel available in either wood or metal. It folds flat and adjusts to fixed angles. The size of painting it will hold is, however, rather limited.

I bought a traditional, robust, solidly built studio easel for £25 second-hand many years ago and I use it constantly. It is made of oak and has the feature of being double-sided. This type holds very large canvases. A studio easel is costly but can last a lifetime. It is cheaper to buy a second-hand one but you may be lucky to find one.

The box easel is undoubtedly the best of all for outdoor painting but is equally practical indoors. With compartments for brushes, paints and medium, it is virtually a travelling studio. I have had my French box easel for more than thirty years and I use it for demonstrations and painting outdoors. Its stability in all weather conditions is excellent. Two sizes are available, but the largest when loaded is rather heavy to carry over a distance. There are several manufacturers of the basic box easel design. All models are costly but you will not regret the investment.

POCHADE BOX

For compactness and easier portability I readily recommend this small unique box for outdoor painting although you may have to shop around before finding one.

In contrast to the bulk of a box easel, the small compact *pochade* box forms a mini travelling studio. Brushes, paints, plus a couple of painting boards all fit inside. The lid forms an easel and the paintings can be carried wet quite safely. You can hold the box while painting in a standing position or rest it on your lap if sitting down. The average sizes of a *pochade* box are about 31 x 23 x 7.5cm (12 x 9 x 3in) or 25.5 x 20.5cm (10 x 8in).

Note: When choosing an easel for use outdoors, remember it will have to withstand heavy handling in all weathers. Don't be rushed into buying and make sure the shop assistant demonstrates assembly and dismantling of the easel and allows you to do the same. Buying an easel is likely to be your most expensive investment, so you want to make certain your choice is the right one.

TRAVELLING LIGHT

How to carry all the equipment and materials for painting landscapes in oils comfortably can be a bit of a problem. My *pochade* box fits into an ex-army valise and a lightweight sketching stool is held in place by the adjustable straps. Wide webbing shoulder straps make carrying the full valise comfortable even over a long distance.

A rucksack which combines a sketching stool is a great asset. The Art Back Pack is one of the best and a much favoured part of my equipment. It meets all the requirements of stability, comfort and lightness as well as the sketching stool being a convenient height. The pack itself is capacious and easy to carry when full.

An oil colour box that includes the facility of support in the lid for a painting panel reduces the amount of separate equipment needed to be carried.

OTHER EQUIPMENT

DIPPERS

Several types and sizes of dippers that clip on to the palette are useful. These are sold singly or in pairs.

BRUSH WASHER

I bought my brush washer many years ago from a dusty old art shop on the Left Bank in Paris. The sediment from washing out brushes collects at the bottom and can be cleaned by lifting out the sieve. I have used it ever since both in the studio and for outdoor painting. Similar brush washers are available from most art shops and are worthwhile pieces of equipment.

PALETTES

The traditional wooden palette comes in three shapes: oval, oblong or kidney. A folding oblong palette has the advantage of folding flat to half size. Spacers enable the palette to be closed and carried with wet paint on it.

A tear-off parchment paper palette is the most convenient. I normally use this type of palette for studio and outdoor painting because I can progress a painting with minimum interruption. For studio work I also use my large, kidney-shaped, traditional wooden palette.

RAGS

A plentiful supply of lint-free rags is essential for wiping brushes and for lifting out. Jumble sales are a good source of material suitable for painting rags.

PALETTE KNIFE

Finally, you will need a cranked-handle palette knife for cleaning off your palette or scraping off paint from your painting that has become 'muddy'.

PENCILS

Finally, a range of pencils, drawing pens, charcoal and conté sticks is useful for making sketchbook studies.

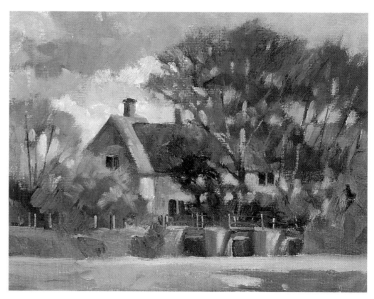

SPRING MORNING, 25 x 17cm (10 x 7in)

CHURCH ACROSS THE FIELDS, 18 x 12.5cm (4½ x 7in)

(Left) A thick solid stick of graphite is my favourite medium for outdoor sketching. Available in four grades, it encourages a broad style of expression as seen in this sketch of Fiddleford in Dorset.

Fiddleford, Dorset

(Right) Carbon pencils make dense matt marks ideal for building up a drawing quickly as demonstrated in this second Dorset sketch.

Sturminster Meadows, Dorset

Mullion Cove, Cornwall

(Left) The medium grade 2B lead pencil is excellent for bold line drawing or shading.

(Right) Although I do not often use a pen I include this sketch to show the delightful effect of an Edding Calligraphy Pen 2.0 on Goldline Chartwell watercolour paper.

Fiddleford Manor, Dorset

(Right) Available in slender or chunky sticks, natural charcoal is the most expressive of all drawing media. My outdoor sketch of summer trees is an example of the blending technique, and lifting out light tones with a putty rubber. Charcoal pencils are not as soft as natural charcoal but give a wide range of beautiful tones. Derwent charcoal pencils are available in three grades – light, medium and dark.

Summer Trees, Fiddleford, Dorset

Conté drawing

(Left) Comparable in expression to charcoal, conté is the most beautiful drawing medium. This sketch is on cream cartridge paper.

(Right) For this carbon pencil sketch of a Dorset field. I have used smooth white card to illustrate the density and texture of marks.

Dorset Field

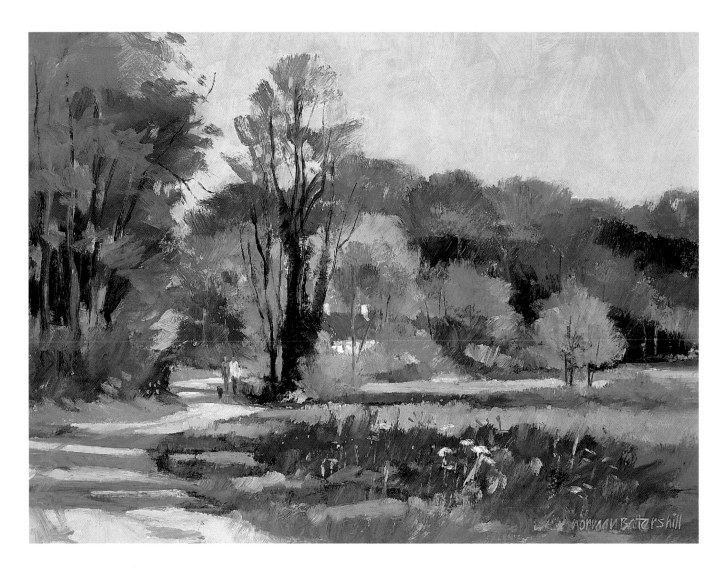

LANE AT ARUNDEL, SUSSEX,
38 x 31cm (15 x 12in)

To increase the effect of a sunny day I stained the board with burnt sienna and left some of the colour showing in the finished painting. The ivy-clad tree provides an important contrast to the horizontals and curves of the rest of the composition.

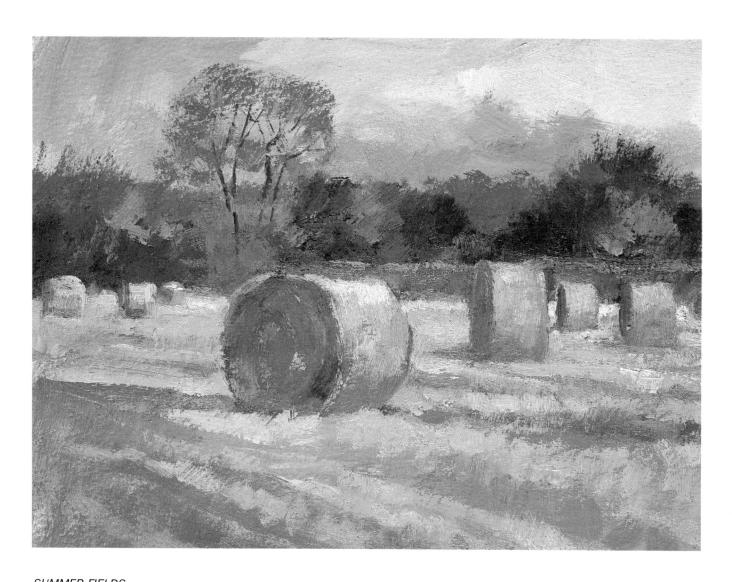

SUMMER FIELDS,
23 x 15.5cm (9 x 6in)

For this small outdoor oil sketch I painted on acrylic
primed Bockingford watercolour paper. The surface was
suited to the texture of my subject and is ideal for dry
brush effects. My colours were ultramarine and cadmium
red for the distant trees and sky, and raw sienna, burnt
sienna, cadmium yellow pale and ultramarine for the bales
and stubble. For the rest of the painting I used the same
combination of colours.

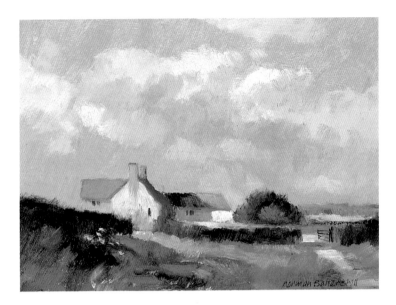

AFTERNOON LIGHT,
31 x 23cm (12 x 9in)

Simplifying by eliminating unnecessary detail adds strength
to a painting. Here the emphasis is on bold shapes and
the pattern of light and dark. An effect of sunlight is
emphasized by the shadow on the white wall.

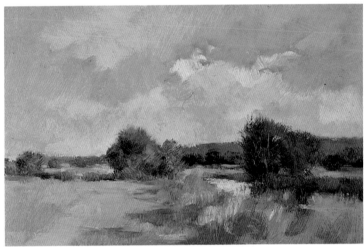

FIDDLEFORD MEADOWS, DORSET,
31 x 18cm (12 x 7in)

Although I have been painting and sketching along this
river for many years I always manage to find a new
subject. The principal elements of landscape, sky, trees
and water combine to form this tranquil scene. By
darkening the river in the foreground, interest is taken
into the painting, adding to the effect of distance.
I painted on hardboard and the colours I used were
cadmium green, raw sienna, ultramarine, alizarin, burnt
sienna and titanium white.

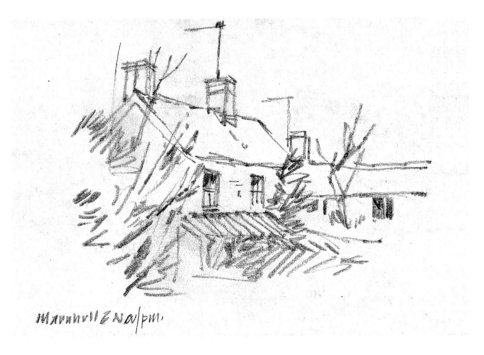

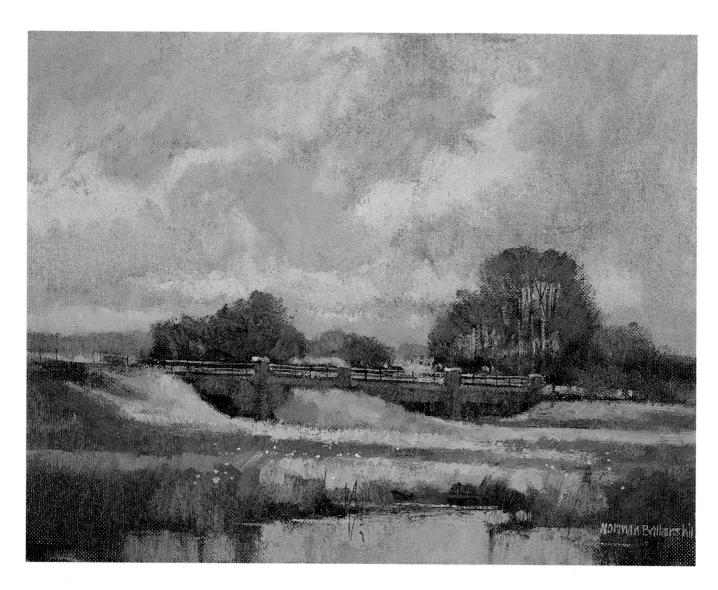

SUMMER DAY, SHILLINGSTONE, DORSET,
38 x 31cm (15 x 12in)

Thinned paint on fine linen canvas produced the
translucent effect of clouds. I lifted out the sunlit areas
with a turpsy rag, softening edges here and there. I
particulary liked the strong composition but was careful
not to let the bridge become predominant. Judging correct
tone values is critical to achieve a sense of light, space
and distance.

CHAPTER TWO

Planning

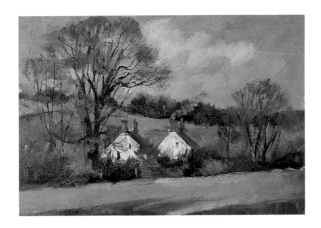

DORSET FARMHOUSE, 25.5 x 20.5cm (10 x 8in)

To reduce the brightness of the sunlit walls, I tinted titanium white with raw sienna.

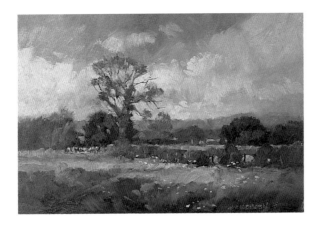

FIDDLEFORD, DORSET, 46 x 31cm (18 x 12in)

Here the elm tree counterbalances the horizontal features.

COMPOSITION

When planning a painting, composition is the first element to consider. You may want to modify your chosen viewpoint but do this carefully – too much alteration can create problems. Make a few exploratory sketches, then you can start painting with confidence.

A harmonious composition also involves the use of colour and tone. If the colour or tone is too light or dark this will detract from the painting. Each feature must contribute to a well-balanced whole.

Composition is the pattern formed by shapes, tone, colour and line. Horizontal lines suggest calm, and trees are a perfect counterbalance. Angled lines are powerful and should be used carefully to ensure harmony. A major part of landscapecomposition is the sky – its colour, intensity and the amount of space it occupies. Just by altering the position of the horizon, you can change the appearance of a scene. The type of cloud most painted is the majestic heap (cumulus) cloud, which with strong side lighting can assume dramatic shapes and tonal contrasts. If overemphasized this will disrupt the composition.

An experienced artist will automatically analyse the composition of a landscape whatever the setting may be. It is easy to alter parts of a subject to improve the composition, but take care not to destroy the essence of the scene which captured your interest.

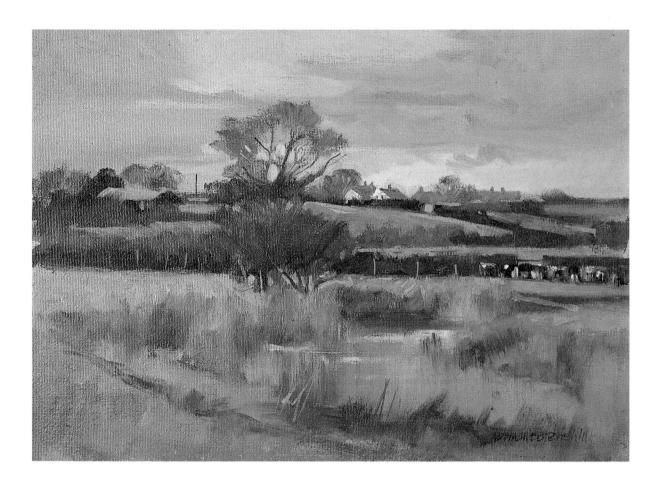

WAITING, 25.5 x 20.5cm (10 x 8in)

This composition is fairly complex and I had to think carefully about how to achieve a balanced arrangement of tone and shape. First of all I decided the area of interest should be the horizon.

I avoided the temptation of emphasizing the water in the foreground and added a touch of light on the bend to take attention into the distance.

For my outdoor painting the colours I used were burnt sienna, yellow ochre, ultramarine, cadmium yellow light, cadmium red and titanium white.

Sometimes it may be an advantage to try out alternative compositions of the same subject. The top sketch has possibilities for transforming into a winter landscape with an atmospheric sky. By raising the horizon line, a much more interesting composition is created in the bottom sketch. Perhaps you may like to develop these sketches into paintings or use them for further ideas.

A *Cadmium green + cadmium yellow pale + white*

B *Viridian + cadmium yellow pale + white*

C *Ultramarine + cadmium yellow + white*

D *Cadmium green + cadmium orange + white*

E *Cadmium green + yellow ochre + white*

F *Cadmium green + cadmium red + white*

G *Cadmium green + burnt sienna + white*

H *Cerulean + cadmium yellow + white*

I *Viridian + yellow ochre + white*

J *Cobalt + cadmium yellow pale + white*

COLOUR MIXING

Knowing the characteristics of different colours leads to a more positive approach to mixing. Quick and effective blending of colours is especially important when painting outdoors, where time may be a critical factor. The following list features colours I generally use for outdoor and studio painting:

CADMIUM YELLOW PALE

A strong, clean, bright, pale yellow. With a touch of viridian added it makes a fresh light green which is particularly useful for accents on grass. The resultant colour will take a lot of white before it becomes chalky. Winsor lemon has similar characteristics.

FRENCH ULTRAMARINE

This is a workhorse warm blue for many artists, myself included. Mixed with cadmium red it makes a deep purple appropriate for giving depth in foliage. The rich dark tone of ultramarine blue is ideal for skies. Adding white produces a strong pale blue although it does not have the same freshness as cobalt or cerulean blue. Adding a touch of viridian to a tint of ultramarine transforms it into a beautiful atmospheric blue.

CADMIUM RED

Mixed with yellows this bright pillar-box red produces a range of russets and bright orange. It is also an excellent colour for modifying green.

YELLOW OCHRE

Because this yellow is slightly opaque, some artists (myself included) prefer the more translucent raw sienna. I also use yellow ochre because it has more strength. When mixed with ultramarine or any of the blues the resulting colour is ideal for greenery.

RAW SIENNA

A delightful earth yellow, but weak in tinting strength. Add a touch to titanium white for accents of light on the landscape and sunlit cumulus cloud.

BURNT SIENNA

A strong red-brown useful for modifying green. Adding bright yellow produces a range of lovely tan colours. Mixed with ultramarine it makes a rich, almost black, colour.

VIRIDIAN

This intensity of this green can be compared to that of Prussian blue. Having learnt how to control it, I now use it extensively. Mixed with yellows, a wide range of vibrant greens can be achieved.

ALIZARIN CRIMSON

A powerful deep-red colour. I mix a lot of white with ultramarine and a touch of alizarin to paint blue skies, to give the blue an atmospheric tint. Alizarin is also a useful colour for modifying green.

TITANIUM WHITE

This white is termed a cold colour because it has a slightly blue cast. Because of its covering and mixing power, titanium white is very popular.

CADMIUM ORANGE

This pure and intense colour is strong enough to be used to modify green and make it warmer.

CADMIUM GREEN

A lovely rich sunny green. Used as a base with other colours, a variety of tints and shades can be obtained.

I sometimes add burnt umber and Payne's grey to my palette. The latter is useful for modifying green and for clouds, but too much is deadening. I use cobalt blue to mix with pale yellow for a subtle green; used with alizarin or cadmium, it makes a delightful purple. For greys add light red, burnt sienna or orange. You are bound to discover your own preferences.

RAIN CLOUD, 35.5 x 25.5cm (14 x 10in)

Here my colours were cadmium yellow, ultramarine, burnt sienna, yellow ochre, cadmium red and titanium white. These colours were used to make greens – yellow ochre and ultramarine/cadmium yellow and ultramarine/cadmium yellow, burnt sienna and ultramarine.

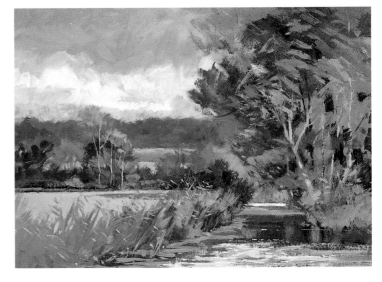

MORNING LIGHT, 38 x 28cm (15 x 11in)

Muted colours, particularly the greens, required careful planning of tone to create atmosphere and distance. Simplification of shapes and accents of light are also key factors in contributing to the overall effect. My colours were viridian, burnt sienna, alizarin, ultramarine, raw sienna and titanium white.

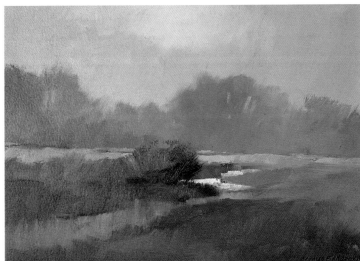

COLOUR AND RECESSION

A layer of atmosphere of great depth surrounds the surface of the earth. This translucent veil influences all the colours of the landscape. Knowing how to modify colour to achieve an effect of distance is one of the most important aspects of landscape painting.

The simplest method of 'greying' a colour is to add black. However, this can result in a dull lifeless colour if added too liberally. Another way is to mix grey from black and white to the desired tone value, then add the key colour. Experimenting with the various blacks and also Payne's grey and indigo, plus white, produces a wide range of warm and cool greys. I seldom use this combination and prefer to mix other colours for grey.

Learning about colour mixing is not confined to the palette. You can develop an eye for colour combinations simply by studying the subjects around you closely. Next time you go out ask yourself, 'What colours would I mix for the sky?' The same question could be applied to the buildings, trees and road and anything else that captures your interest. Everywhere you look there are lessons to be learned in colour mixing.

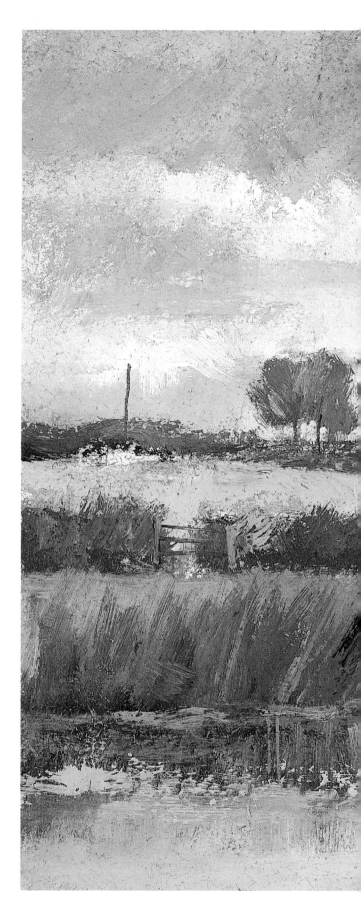

THE BRIDGE, 38 x 28cm (15 x 11in)

This is an outdoor painting of a simple subject but with plenty of interest.

Card primed and stained with burnt sienna provided a warm tinted ground on which to work. This made it easier to judge tone values and contributes to the overall harmony. I left some of the ground colour showing in the finished painting.

The colours used were cadmium yellow, ultramarine, burnt sienna, alizarin, cadmium green and titanium white.

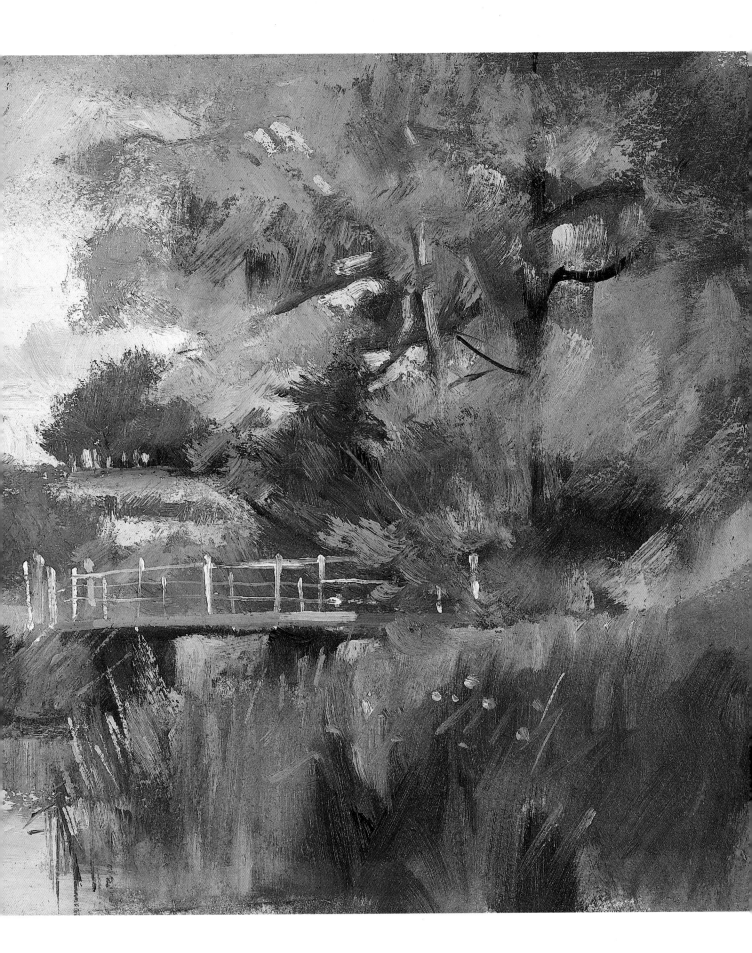

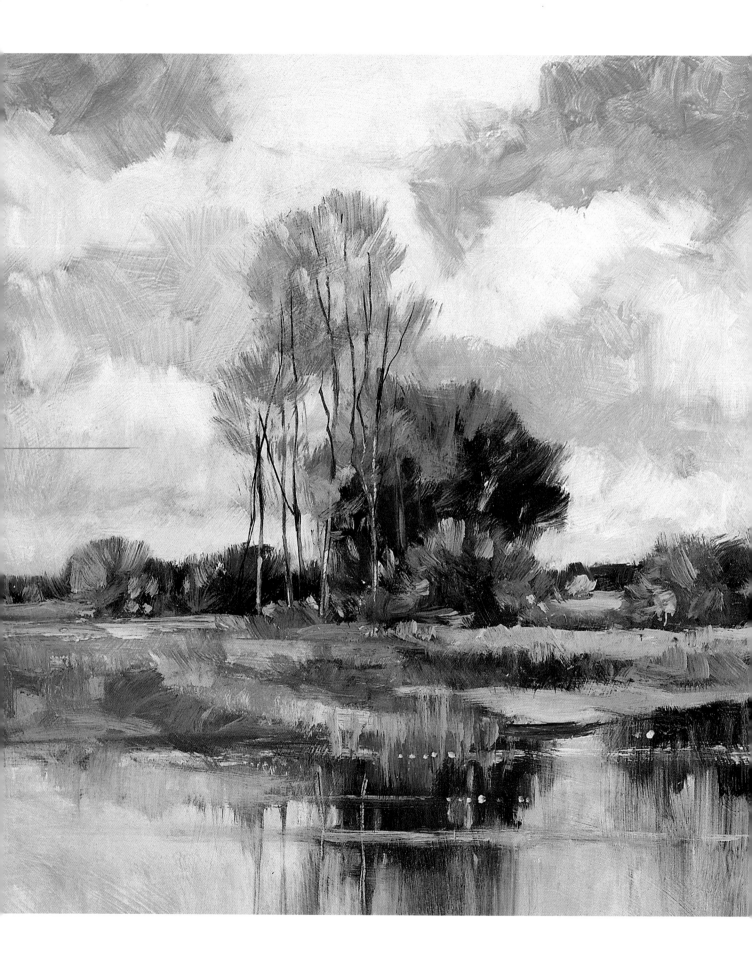

SKY, TREES AND REFLECTIONS,
38 x 31cm (15 x 12in)

I have combined the principal elements of sky, trees and water into a simple composition of verticals and horizontals. Calm water and still reflections add to the atmosphere of this tranquil scene created in the studio. Slender trees on the left give a feeling of distance and depth to the sky, and contrast with the tree mass in the middle distance.

The colours I used for the sky were alizarin, ultramarine, cadmium red, burnt sienna and titanium white. For the landscape the same colours were used with the addition of cadmium yellow pale.

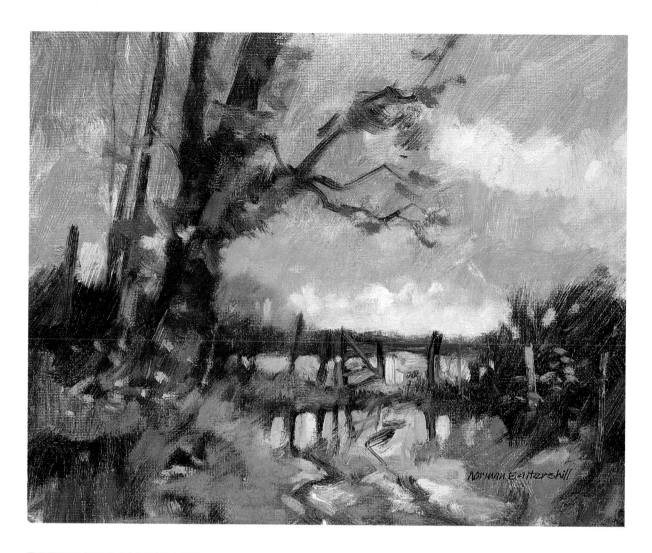

DEPTH IN LANDSCAPE

A sense of depth in landscape painting is achieved by applying the principles of recession. Whatever the subject it can be divided into three separate planes: foreground, middle distance and distance.

Note how objects appear to be smaller and closer together as they recede. The illusion of depth has the same application to clouds. They too appear smaller and closer together with recession. Graduating the tone from dark in the foreground to light in the distance will help to give the illusion of depth. However, including too many subtle changes in tone will make a painting look flat and dull. Simplifying into distinct planes creates a strong composition, but care must be taken that the contrasting divisions do not look like cardboard cut-outs with hard edges. The flow from one plane to another must appear natural.

NOVEMBER, 38 x 31cm (15 x 12in)

To capture the mood of a rugged wet wintry day I used bold brushwork and minimal detail. Although the principal interest is in the foreground, an open gate joins up with the dark horizon and the sky in the distance.

My colours were ultramarine, yellow ochre, burnt sienna, alizarin, burnt umber and titanium white.

SKETCHING OUTDOORS

Your sketchbook is the means of an invaluable accumulation of knowledge and reference material. Try to get into the habit of using it as often as possible to record scenes and anything that may attract your interest. These sketches and jottings will come in useful when you paint in the studio later on. Drawing need not be the rather dull discipline it is sometimes considered to be. Far from being an unnecessary exercise, with a developed sense of awareness and harmony between hand, eye and mind, it can be both pleasurable and immensely satisfying.

Sketching outdoors as often as possible also encourages spontaneity of expression. The application of this asset to your painting has obvious advantages.

Learning from a failed sketch or painting is a natural part of an artist's progress so it does not matter if you make mistakes.

CHOOSING A SUBJECT

The appeal of a subject can depend entirely on the effect of light or atmosphere. A subject or scene that arouses just a faint glimmer of interest one moment might, at a different time of day, be transformed into something breathtakingly beautiful or startlingly dramatic.

Outdoor sketches of seemingly ordinary aspects of the landscape may have potential as studio paintings depending on your creative ability and imagination.

It is a mistake to assume that just because you have been to the same place several times to paint or sketch you have exhausted all the possibilities. The more familiar you become with an area the more new subjects you will discover.

Autumn and winter change the appearance of the landscape. There is no reason to hibernate. Keeping warm and restricting your paintings to a small size, or just sketching outdoors, widens your experience and understanding of the ways of nature.

Slowly scanning the landscape with a viewfinder helps to isolate areas, making it easier to find a subject that interests you. Or as I do, select a subject without the viewfinder and then perhaps use it to confirm your choice is the right one.

Having made a decision, think about the composition. Can it be strengthened by omitting some of the detail? If you are unsure what to leave out, a few small sketch alternatives will help you to be selective and simplify. Including too much detail results in monotony and the spirit of the subject will be lost.

DRAWING MEDIA

You are now ready to start, but what drawing medium will produce the result you wish to achieve? When I go out sketching I carry a variety of materials in a compact pencil box, including a piece of willow charcoal, a soft carbon pencil, a graphite pencil, a 7B lead pencil, and a retractable sharpening blade. To prevent charcoal drawings from smudging it is necessary to keep an aerosol fixative in your kit. All these items plus cartridge paper sketchbooks take up very little space and give me the freedom to select whichever seems most appropriate for the chosen subject.

The pleasure of drawing is considerably enhanced by using a medium that handles easily and suits your particular style of expression. If you find drawing with the point of a lead pencil inhibiting, try changing to a broader medium of carbon pencil, charcoal or graphite which may start you off in a new and exciting direction. Conté, felt-tip pens, nib pens and brush and ink are all worth trying in order to extend your knowledge of the range of drawing media.

Working to a manageable size also will also help you to build your confidence. My sketchbooks are 15.5 x 10cm (6 x 4in), 22 x 16.6cm (8½ x 6in) and 27 x 20.5cm (10½ x 8in). I tend to use the smaller sizes most frequently.

Drawing is an essential element of landscape painting and learning to master different media is a great advantage. The sketches on page 14 illustrate some of the principal drawing media.

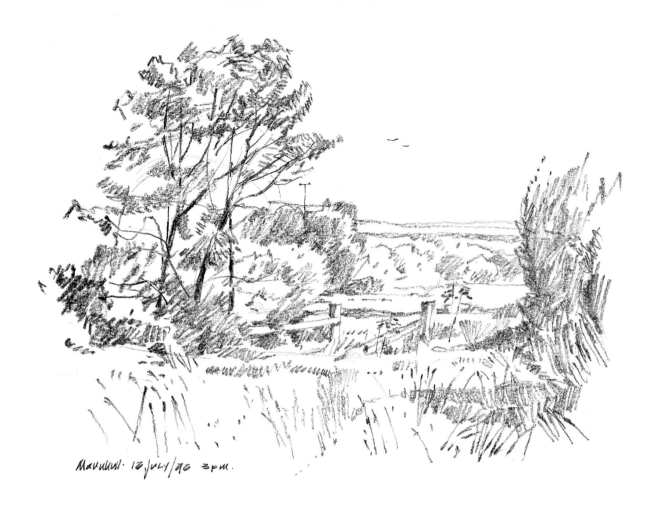

Marshwood. 16 July 90 3pm.

SUMMER FIELDS, 28 x 20.5cm (11 x 8in)

(Above) This delightful landscape is within a short walk of my studio, and while I sketched, a magnificent pair of buzzards drifted lazily in the summer air. For this sketch I used a 6B graphite stick on fairly smooth cartridge paper.

THE STOUR, FIDDLEFORD, 12.5 x 9cm (5 x 3in)

(Below) Black conté and white soft pastel on tinted paper are ideal for making small quick sketches. Here I used black conté first, then fixed it to prevent the soft pastel from smudging into it.

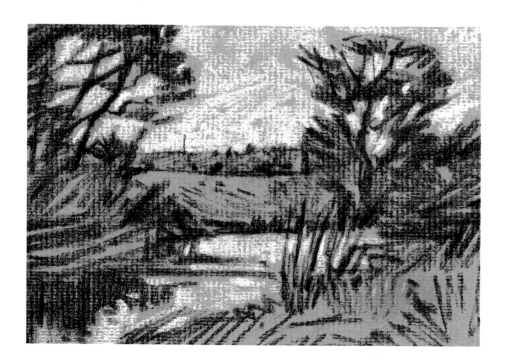

BASIC PERSPECTIVE

Perspective is a fascinating and complex geometric system, but understanding one or two basic principles to begin with is all that is necessary.

Perhaps the most confusing aspect for some is making the perspective of buildings look convincing. The easiest way to determine the angle of sloping lines is to check against your eye-level. Hold a pencil horizontally a short distance in front of your eyes to determine your eye-level or horizon line. The system most used is the principle of two-point perspective. This is best demonstrated by viewing a building from a three-quarter angle, when both sides have a separate vanishing point on the horizon (see page 66). A ruler or set square makes it easier to locate a vanishing point and to set out converging lines, but it is best to avoid a tight mechanical drawing.

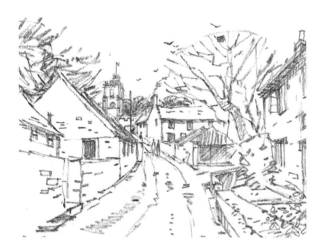

DORSET VILLAGE, 15.5 x 10cm (6 x 4in)

Perspective plays an important part in creating a sense of recession. Here, the lane becomes narrow and buildings appear smaller and closer together as they recede. By comparing the size of the cottages in the middle distance to the church tower we are aware not only of distance but scale as well.

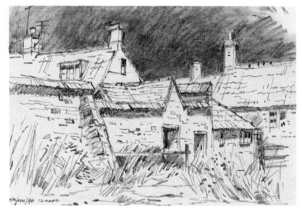

COTTAGES, 23 x 18cm (9 x 7in)

For my outdoor sketch I used graphite pencil on grey writing paper. I was fascinated by the conglomeration of angles, textures and shapes in this corner of a quiet Dorset village.

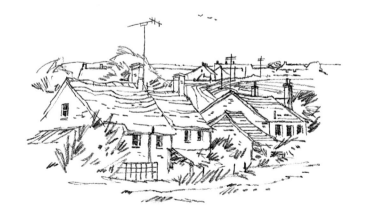

MARNHULL, DORSET, 25.5 x 15.5cm (10 x 6in)

Your drawings do not necessarily need to be potential material for studio painting. Every sketch is an exercise in observation and developing awareness of light and atmosphere.

Skies

The sky determines the mood and atmosphere of landscape and yet is probably the most neglected element of landscape painting. Throughout this book I have emphasized the importance of working directly from nature, and learning about skies is no exception. Clouds require as much careful thought in a composition as the landscape. Consideration must be given to the balance of shape, tone and colour. If any one of these is too assertive the sky

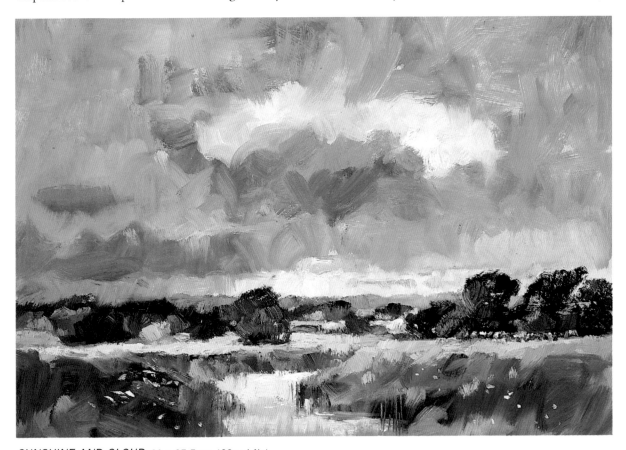

SUNSHINE AND CLOUD, 60 x 35.5cm (20 x 14in)

in your painting will not relate to the landscape. A piece of humble charcoal is the most versatile medium for capturing fleeting moments of light and atmosphere. A soft grade graphite or carbon pencil is also useful for expressive studies. Some examples of outdoor oil sketches are included on page 35.

Your first sky studies should not be too ambitious. Start by selecting an interesting area of cloud and include a small part of the landscape to give scale. The principles of perspective also apply to clouds so try to get a feeling of recession by diminishing the size of the clouds going into the distance. As you paint think of the clouds as misty forms floating in space.

CLOUD TYPES

A simple visual classification of cloud types was formulated by the London pharmacist Howard Luke in 1803 and remarkably the system is still in use today. The following are the main cloud shapes:

Heap (Cumuliform)
Layer (Stratiform)
Feathery (Cirriform)

There are other cloud types but they are all based on these three distinctive formations.

Before you begin painting or drawing, determine the direction of the light, which must be constant throughout your painting. A sunny, clear day will define the cloud forms by contrasts of light and shade. When painting outdoors where the effect of light and shade keep altering, quickly establish the pattern of light and shade and try not to be tempted to make drastic alterations.

MIXING CLOUD COLOURS

The base colour of clouds is always grey, which means that when analysing cloud colour you only need to determine what kind of grey. Mixing black and white direct from the tube results in a bland grey, but adding a touch of another colour can turn

it into a beautiful shade. You may like to make a colour chart to keep as an instant reference for shades of grey when painting clouds.

When mixing the paint, always start with white and then add a touch of black. Try the following combinations and experiment using different combinations by adding a slight touch of other warm colours to your grey mixes:

White + Black + Burnt Umber
White + Black + Yellow Ochre
White + Black + Cadmium Red

Other cloud colours to try are:

Light Red + Yellow Ochre + White
Burnt Umber + White
Cobalt Blue + Light Red + White
Ultramarine + Vermilion + White
Raw Sienna + White

The last colour mix suggests the colour of sunlit clouds, but be careful not to use too much yellow. The blandest of blue skies will have a touch of red or yellow from the sun.

Remember to add a touch of the sky colour in your landscape colours to create a harmonious link between the two elements.

A series of studies devoted to skies can be a wonderfully exciting project. Your sky studies need not be large – a proportion of 25.5 x 18cm (10 x 7in) is a good size. On a cloudy and breezy day you can paint or sketch several different studies from one spot as the clouds move and change form. Including a small part of the landscape gives scale to the sky and also a sense of recession. The endless variety of cloud patterns makes landscape painting exciting. Clouds are continually changing shape, patterned by the movement of wind. This may seem to be a hindrance when painting outdoors, but working under pressure often produces a lively and spontaneous painting. The sky overhead will always be darker than on the distant horizon and this helps

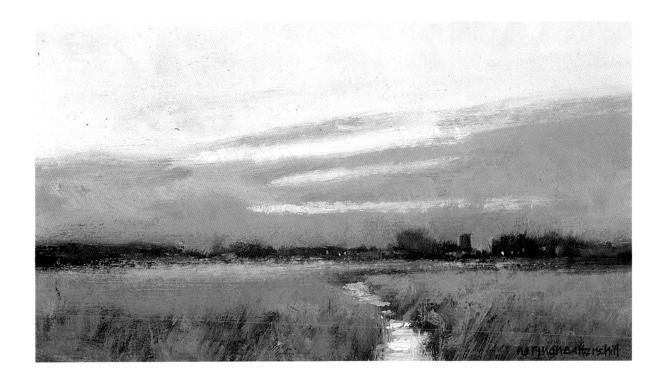

DAWN, 38 x 20.5cm (15 x 8in)

A studio painting of an imaginary landscape at daybreak. It is one of my favourite subjects. The lavender-colour sky is a subtle complementary to the green meadows, creating harmony between the two. My colours were viridian, raw sienna, alizarin, ultramarine and titanium white.

to create the effect of recession. But even darker cloud is generally much lighter in tone than any part of the landscape. Judging the correct tone of the darkest cloud first makes it easier to establish the middle and light tonal scale not only of the sky but of the landscape as well.

Simplifying cloud shapes is just as important as simplifying tone values. Half closing your eyes reduces tonal pattern to the essentials. Try to identify the big shapes and the bold contrasts. Keep to the minimum of tone values as too much modelling of cloud form will result in an overworked fussy sky.

The paintings in this book clearly illustrate how sky influences the mood and atmosphere of landscape. It is essential to achieve a sense of natural harmony between sky and landscape in a painting. As you become more experienced you can train your visual memory to retain the effect of mood and atmosphere so that you are able to re-create it in a studio painting. This is the most valuable asset a landscape painter could wish for.

SKY STUDY, 25.5 x 20.5cm (10 x 8in)

The action of air currents and air temperature can quickly alter the shape of clouds, so I established the principal cloud pattern first. Judging the tone value of the landscape against the sky was then a lot easier. I particularly liked the effect of the church tower silhouetted against the sunlit cumulus clouds.

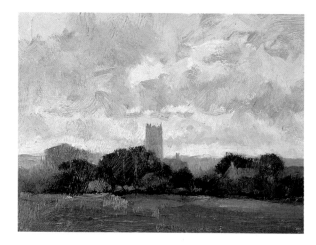

SKY STUDY TWO, 25.5 x 20.5cm (10 x 8in)

The clouds in this painting are also fair-weather cumulus but the mood of the landscape is quite different from the first study. Intermittent sunshine transformed the landscape into light and dark contrasts. My colours for both studies were ultramarine, alizarin, burnt sienna, cobalt blue and titanium white.

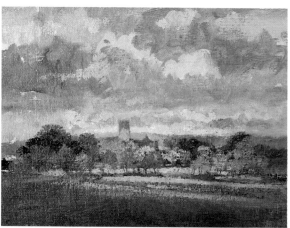

OCTOBER SKY, 25.5 x 20.5cm (10 x 8in)

A winter elm and flooded fields add to the atmosphere, but the strip of sunlit cloud in the distance is the key to the subject. The low tones of the landscape increase the effect of light in the sky. My colours were burnt sienna, alizarin, raw sienna, ultramarine and titanium white.

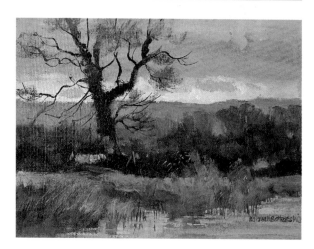

SUMMER SKY, 28 x 23cm (11 x 9in)

This demonstration is on a canvas-mounted board commercially prepared with acrylic priming. The technique of wiping out cloud shapes with a clean soft rag is quick and particularly useful when painting outdoors. I used the minimum of titanium white.

STEP ONE

(Right) Ultramarine diluted to watercolour consistency establishes the general pattern of big cloud shapes and blue sky. While this is still wet more clouds are created by lifting out with a piece of clean rag dipped in white spirit.

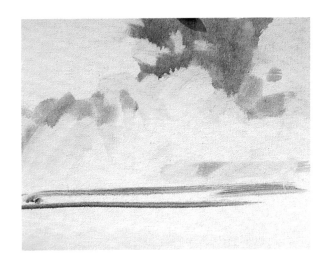

STEP TWO

(Left) To achieve the correct tonal relationship between sky and landscape, I established the distant hills next with a mixture of ultramarine with the addition of a little white. The field is raw sienna, ultramarine and a touch of white. For the foreground shadow I added a little burnt sienna and ultramarine. Next I worked on the cloud shadows, mixing ultramarine, alizarin and white, softening edges here and there with the brush and a rag.

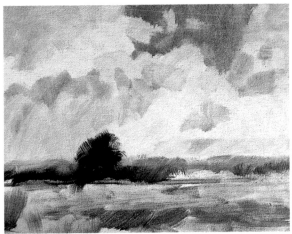

STEP THREE

(Right) The streak of sunlight is wiped out and painted with cadmium yellow pale, raw sienna and white. This technique enhances clarity of colour. Cobalt blue is added to the hills to increase recession.

The colours used were ultramarine, alizarin, raw sienna, cadmium yellow pale, burnt sienna and titanium white.

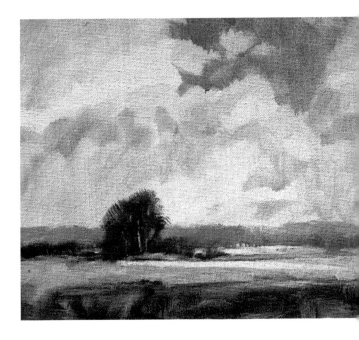

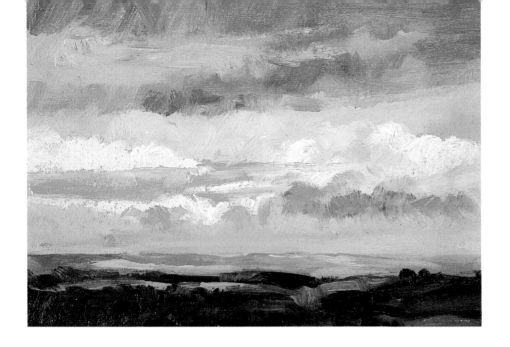

SKY STUDY, WOOLLAND, 25.5 x 20.5cm (10 x 8in)

This cloud study was painted outdoors on a blustery October afternoon. I had already stained the primed board with thinned raw sienna, creating a warm middle tone to work on. Sunlit cumulus cloud in the middle distance provided a contrast between light and dark clouds.

Painting cloudy skies outdoors is always an exciting challenge encouraging swift brushwork and decisive colour mixing. Successfully capturing an effect of aerial atmosphere adds to the pleasure. The colours used were cobalt blue, raw sienna, burnt umber and titanium white.

SUNLIT CLOUD, 11.5 x 14.5cm (4 x 5in)

Charcoal and soft pastel are versatile media and ideal for outdoor sketches as shown here.

STEP ONE
First, the composition was roughed in with charcoal.

STEP TWO
The warm grey paper is a middle tone. Darker tones were established with charcoal.

STEP THREE
Next I fixed the charcoal so that it would not mix with the white pastel and smudge. Finally, I added white pastel to create light on the clouds. I could then more easily judge how dark the final touches of charcoal should be. The grey paper was left showing here and there. This technique combining the two media is quick and effective.

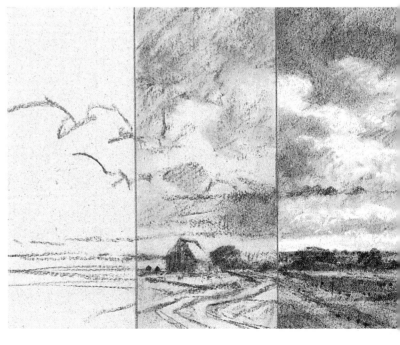

1 2 3

CLOUD STUDY, BLACKMORE VALE,
29.5 x 20.5cm (11 x 8in)

The cloud pattern was constantly changing when I did this outdoor study, making it necessary to simplify into big shapes and minimize tone values. Smaller clouds on the horizon enhance the sense of recession. For my sketch I used carbon pencil on cartridge paper.

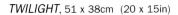

TWILIGHT, 51 x 38cm (20 x 15in)

For my imaginary studio painting I endeavoured to capture the soft elusive atmosphere of fading light at the end of the day. First of all I applied a diluted stain of raw sienna over the primed board giving a warm base to work on. The composition and subject is extremely simple and the success of the painting depends entirely on getting tone values right.

To increase the feeling of stillness and depth, I added tiny touches of light in the far distance. Greater transparency in the sky is achieved by a stain of colour instead of opaque paint. My colours were alizarin, raw sienna, viridian, ultramarine and titanium white.

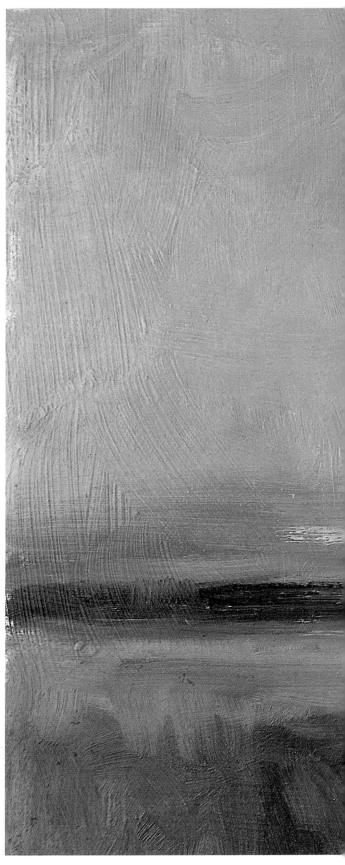

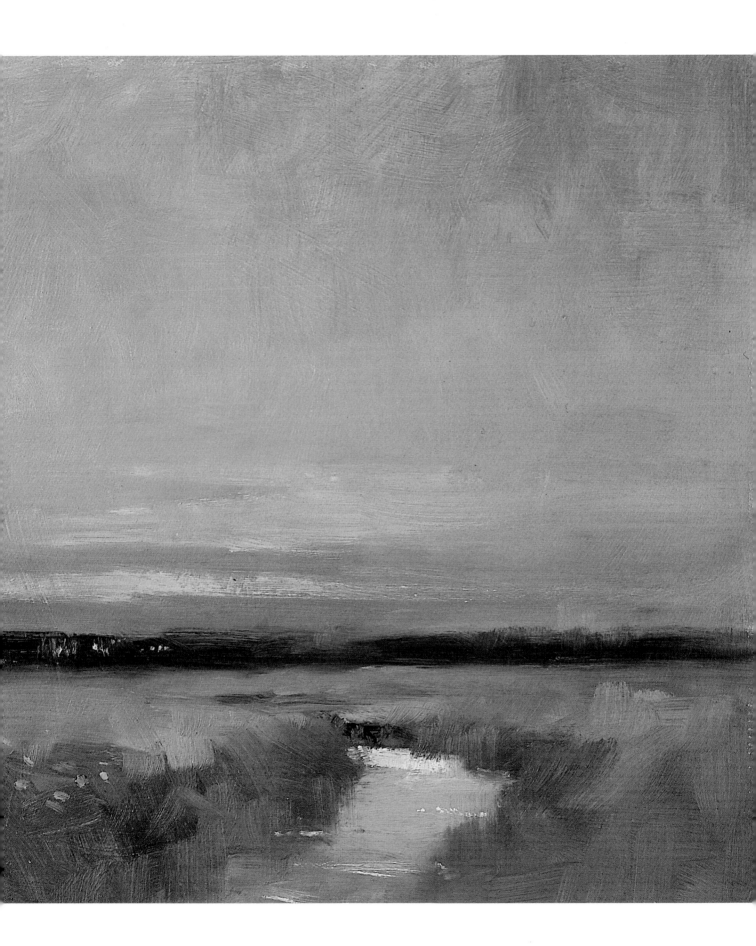

RAIN, 20.5 x 15.5cm (8 x 6in)

For this painting I wanted to achieve the effect of a
downpour without having actually to show lines
depicting rain.

The area of misty sky is very small compared to the
rest of the painting, but cover it up and you can see how
the brushwork adds to the mood of a rainy day. I do not
normally work to such a small size, but making a drastic
change gave me a new challenge. I was careful not to
include detail which would have detracted from the
impression I intended.

The few colours I used in this case were ultramarine,
alizarin, raw sienna, viridian and titanium white.

SUMMER FIELDS, 25.5 x 20.5cm (10 x 8in)

When I began this outdoor painting the sky was a travel-brochure azure blue. To modify the brilliant colour I painted light grey into an underpainting of ultramarine and white while it was wet. This also helped to give recession to the sky. The blue in the foreground shadows creates a harmonizing link between the elements of sky and landscape. Although my subject was rather ordinary, the contrast of light and dark transformed it into a beautiful corner of the landscape.

My colours were ultramarine, alizarin, cadmium yellow, cadmium yellow pale, burnt sienna, raw sienna and titanium white. I used three different yellows in order to retain freshness of colour.

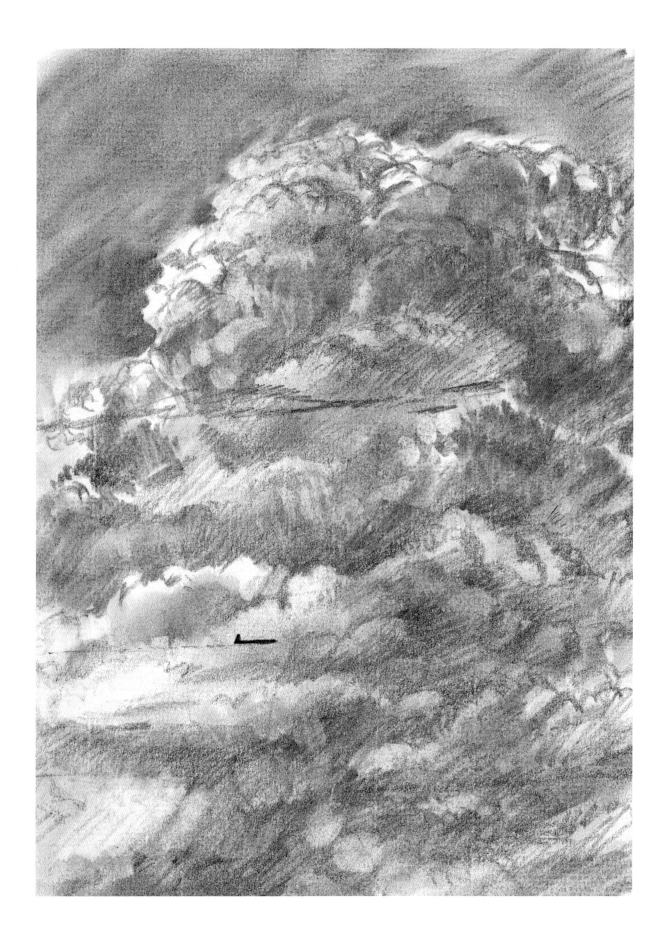

PAGEANTRY OF THE SKIES, 25.5 x 18cm (10 x 7in)

(Left) I imagined an immense heap cloud soaring to a
colossal altitude as a subject for this charcoal drawing.
Wisps of thin cloud moving across the dramatic heap
formation enhance the sense of distance, height and
movement.

The airliner was drawn with a carbon pencil. Cover it
up and see how important it is in giving an immediate
feeling of scale. Flying through cloud in a plane we
become aware of the wonderful mistiness and quality of
diffused light. Whenever I paint clouds I try to remember
that experience.

DORSET VILLAGE, SUMMER, 60 x 41cm (20 x 16in)

(Below) Achieving a harmonious balance between
landscape and sky is especially important when one part
occupies the greater space. Scale is important too, and
in this instance the church tower gives an immediate
sense of distance and height in the sky. Except for
effects of bright sunlight the landscape is always darker
in tone than the sky. Deciding what these tone values
should be at the roughing-in stage gives a good base to
build on.

My colours were cobalt blue, ultramarine, raw sienna,
cadmium yellow pale, cadmium red and titanium white.

SKIES **43**

CHAPTER FOUR

Water

MAKING STUDIES

A 30.5 x 23cm (12 x 9in) sketch pad is a good size to use for water studies. Charcoal, soft pencil and conté are particularly suited to sketching a variety of water subjects. The technique of lifting out highlights from a charcoal drawing with a putty rubber is ideal for rendering light on water.

MOVING WATER

Tumbling and rushing water forms a complexity of confusing shapes. Selecting a small area and isolating it with a viewfinder makes it much easier to concentrate. Look for the larger shapes and pattern of movement and avoid fussy detail. A photograph taken at a fast shutter speed reveals the beauty of the water's movement. For the abstract painter, the pattern of reflections in moving water has endless possibilities (see page 52). Including the sea in a landscape painting is exciting but difficult. Changing light and continuous movement is a great challenge. Start with charcoal sketches and small oil studies before embarking upon more adventurous sea and coastal subjects.

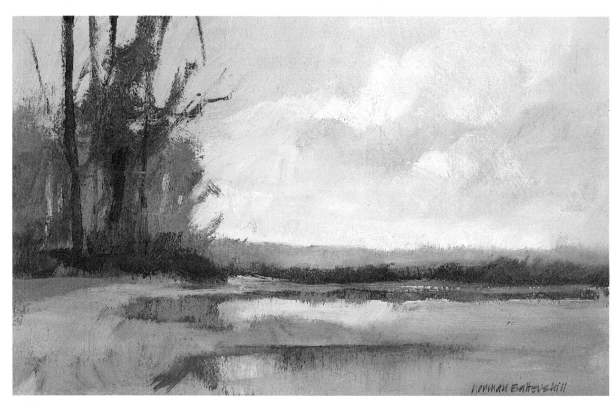

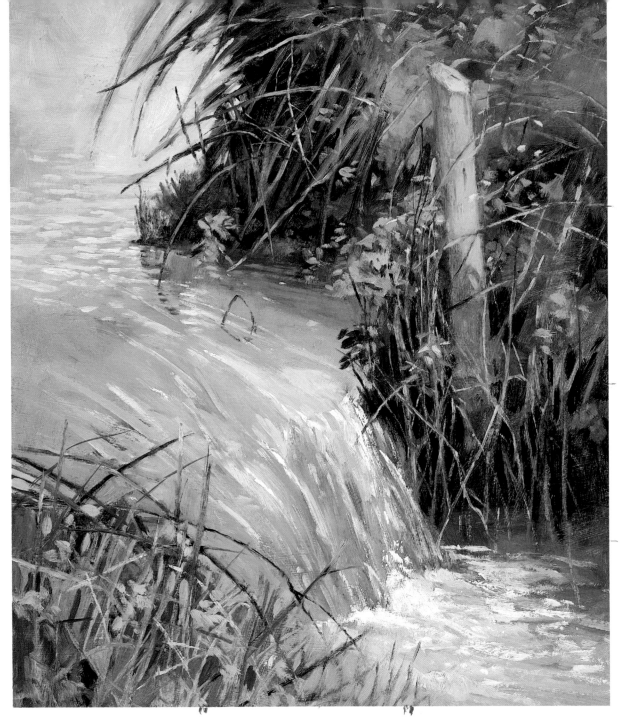

STILL WATER, 31 x 20.5cm (12 x 8in)

CASCADE, 62 x 46cm (24 x 18in) *(try 12×9)*

(Left) The composition of this subject could not be simpler. Creating a mood is more important than attention to detail. Big shapes form bold patterns, adding to the strength of the design. The sky was roughed in first. I was then able to judge the tone of the landscape more easily. If you cover up the trees on the left you can see how important this dark area is.

My colours were ultramarine, cadmium red, viridian, raw sienna and titanium white.

(Above) This painting, based on a photograph of a stream in flood, shows different water textures. I stained the primed board with raw sienna for the water and burnt sienna for the bank. At the top left I created a sunlight effect and retained some of the stain in the calm middle section.

The colours were alizarin, burnt sienna, cadmium yellow, cadmium green, ultramarine, cobalt blue, viridian and titanium white.

STILL WATER

When water is slow-moving or still, special attention must be given to its tonal value. Reflections in perfectly still water have the quality of mirror images, so unless the overall tone of reflected sky and images is slightly darkened the painting will look upside-down. Even a puddle which is painted too dark or too light in tone will look like a hole in the picture.

If an expanse of water is painted the same tone in the foreground as in the background it will appear to fall out of the picture. This can be corrected by slightly darkening the foreground.

TIDAL RIVER, 28 x 23cm (11 x 9in)

A fast-flowing tidal river was my subject for this painting.

STEP ONE

A wash of thinned ultramarine blue was laid in first to determine cloud pattern. For the darker cloud I mixed raw sienna with a touch of ultramarine and white. Towards the horizon the colours used were ultramarine, alizarin and titanium white. By working forward from the distance it is easier to judge tone values.

The next step was to indicate the water in the foreground with thinned ultramarine. This darkened area is necessary to prevent the water appearing to fall out of the painting. I then roughed in the reflections.

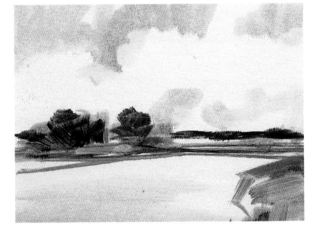

STEP TWO

To assess the correct tone of the water I added more work to the landscape. The sunlit field is raw sienna, cadmium yellow pale and white. Painting the distant hills with cobalt blue added to the effect of recession.

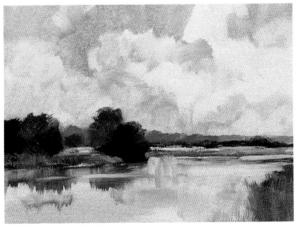

STEP THREE

From this viewpoint the river curves to the right but I felt that the composition could be improved by taking interest into the painting. To achieve this I placed a shrub on the bend, creating a small contrast of dark against light as the river turns. The strong current flowed more or less in the middle of the river and this gave me the opportunity to contrast calm against movement, adding further interest.

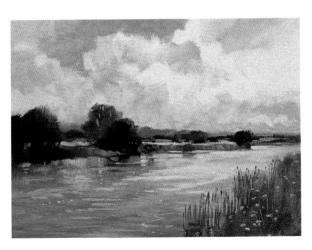

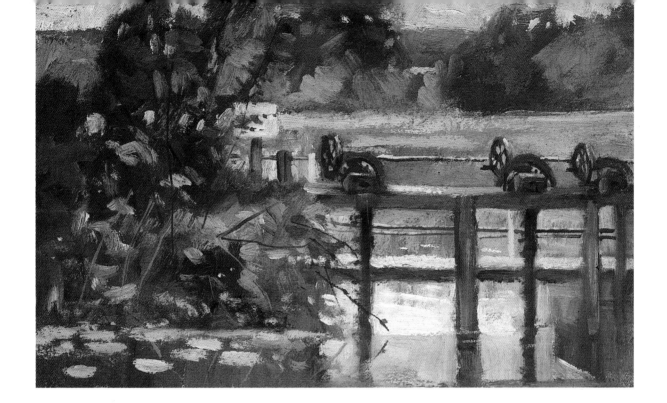

Calm water is often disturbed by a breeze, ruffling and making the surface sparkle with light. Adding this delightful effect in a painting is a way to make the water look flat and creates a sense of atmosphere.

The principles of composition concern reflections in the same way as other aspects of landscape painting. This applies not only to creating harmonious shapes but also to tonal values. A simple rule to remember is that if the object of the reflection is dark, the reflection should be slightly lighter, and a light object will have a slightly darker reflection. You can check this by placing several light and dark objects on a mirror placed on a table.

Including a calm stretch of water in a painting suggests tranquillity. For this kind of subject great attention must be given to the mood of the sky. Horizontal flat layers of stratus cloud increase the calm atmosphere. Alternatively, the bold, rounded forms of cumulus clouds will contrast and emphasize the flatness of an area of water.

Landscape absorbs light but water reflects light like a mirror. You may have noticed that the sky over the sea is often brighter than over the land. This can often be seen several miles before approaching the coast. The inclusion of water in a landscape painting does not necessarily mean it should assume

SLUICE GATE, FIDDLEFORD, 28 x 18cm (11 x 7in)

Subtle contrast between the upper level of calm water and the lower level of moving water was the motif for this small outdoor oil study. I painted on card stained with burnt sienna diluted with turps. For the foreground calm water I mixed ultramarine with cadmium red. The lower level is cadmium yellow and ultramarine. These colours are also mixed for foliage and the fields, creating colour harmony. Intimate corners of the landscape are there waiting to be discovered by the observant artist.

importance. Even a small area of water is sufficient to create interest and atmosphere.

Wet streets after rain are rich in colour, giving the effect of a varnished painting. Atmosphere can be created with the simplest street scene in the rain but this is often overlooked as a potential subject.

Flooded fields can transform familiar landscapes into wonderful painting subjects. The meadows adjoining the River Stour not far from my studio are often flooded in the winter months. Whenever this happens, farm gates, hedges and trees reflected in an expanse of still water offer endless scope for a variety of compositions.

STILL WATER, 31 x 23cm (12 x 9in)

On the other side of this footbridge the water drops with a powerful white force. However, I chose the upper level because it suggests tranquillity. The clear mirror-like reflections attracted me to this subject on the River Stour in Dorset. I have omitted a lot of detail so that I could concentrate on making the most of the big slabs of colour and on a feeling of distance.

I painted the sky first then roughed in all the main tones, relying on brushwork to suggest the texture of foliage. This is an effective contrast to the smooth still pool of water. My colours were burnt sienna, cadmium yellow, ultramarine, raw sienna and titanium white.

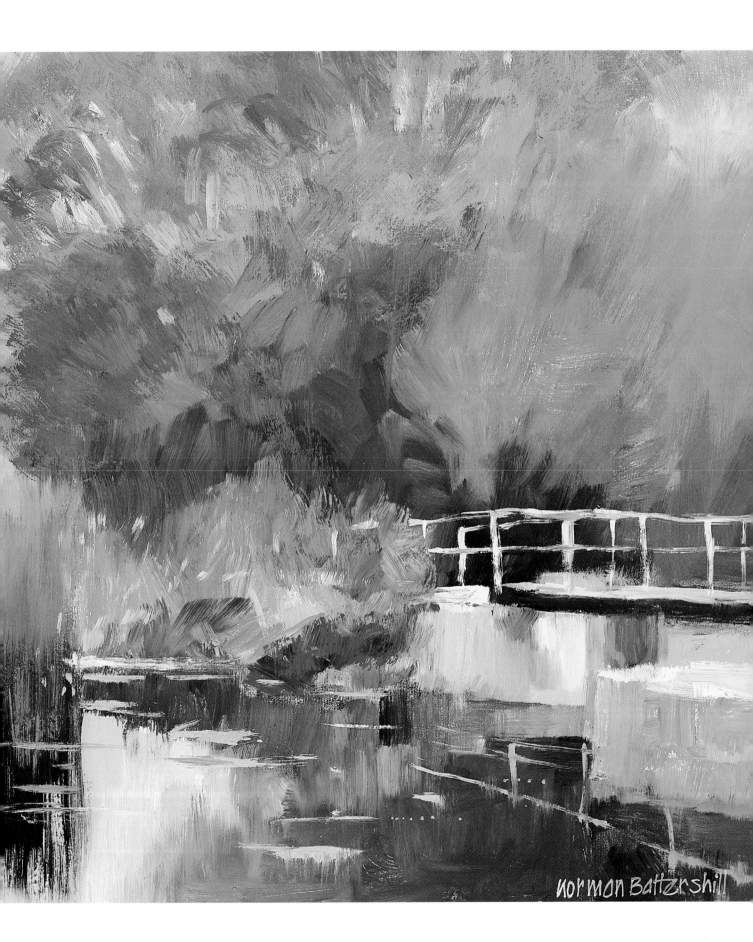

STUDLAND, DORSET, 25.5 x 20.5cm (10 x 8in)

The sea cannot be excluded from this section on water. A summer day with a gentle incoming tide below sunlit cliffs offers a wonderful chance to emphasize sunlight and shadow. In this scene, the foreground shallow water caught the sun, creating a lovely play of light.

For the sea I mixed ultramarine and a touch of raw sienna. I used the same colours for the sunlit cliffs. The other colours were cadmium red, cadmium yellow, cobalt blue and titanium white. One of the most important aspects of this painting are the shadows on the distant cliffs. I had to be careful not to make them hard along the edges, otherwise this area would have been predominant. While the paint was wet I softened the shadows and added cobalt blue to create depth. The day was breezy with quite a lot of white-topped waves. If too many are included the painting becomes fussy; just a few are sufficient.

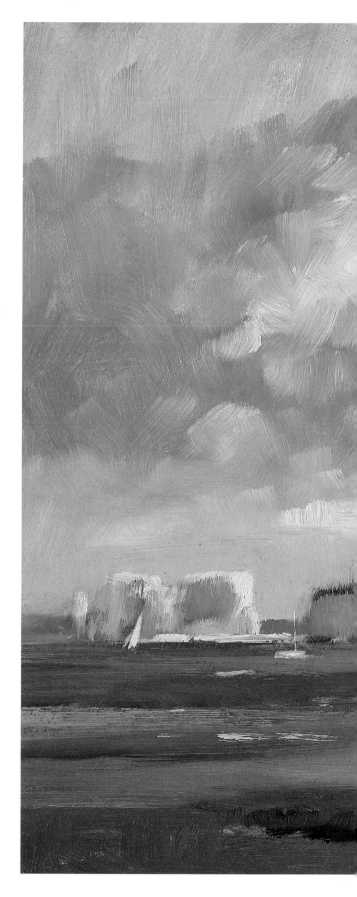

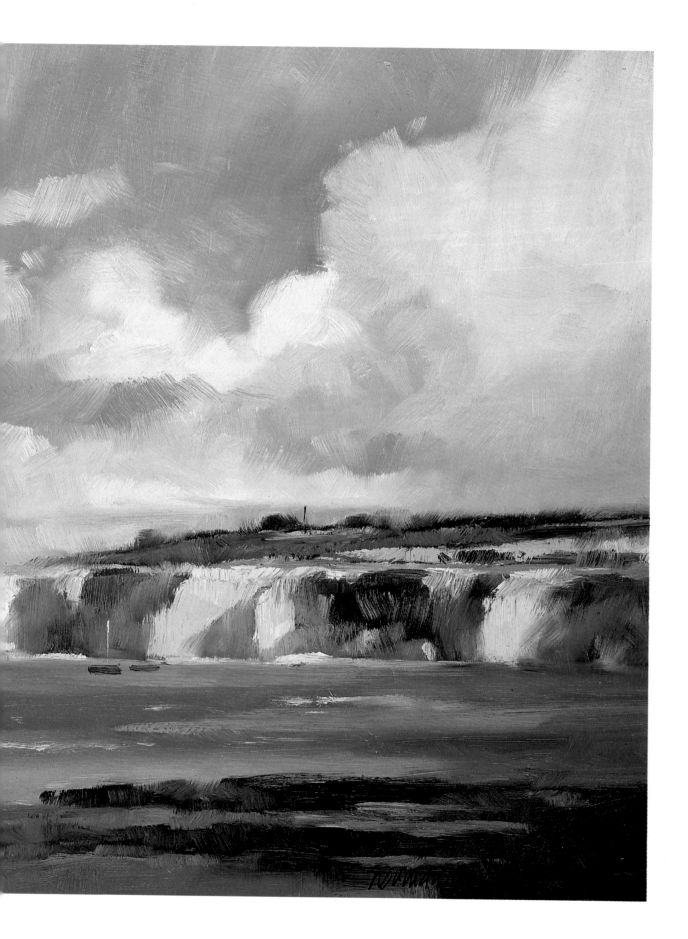

REFLECTIONS, 12.5 x 10cm (5 x 4in)

Moving water is often too fast for us to define the shapes.
A black and white photograph in sharp focus at high
shutter speed 'freezes' the flow, enabling a close study of
the wonderful abstract pattern. I omitted a lot of
unnecessary detail in order to concentrate on the principal
pattern. Notice how the reflections open out and become
wider the nearer they are to you.

Making careful pencil studies this way considerably
enhances our knowledge of moving and still reflections.
As with all aspects of painting, look for the important
dominant shapes.

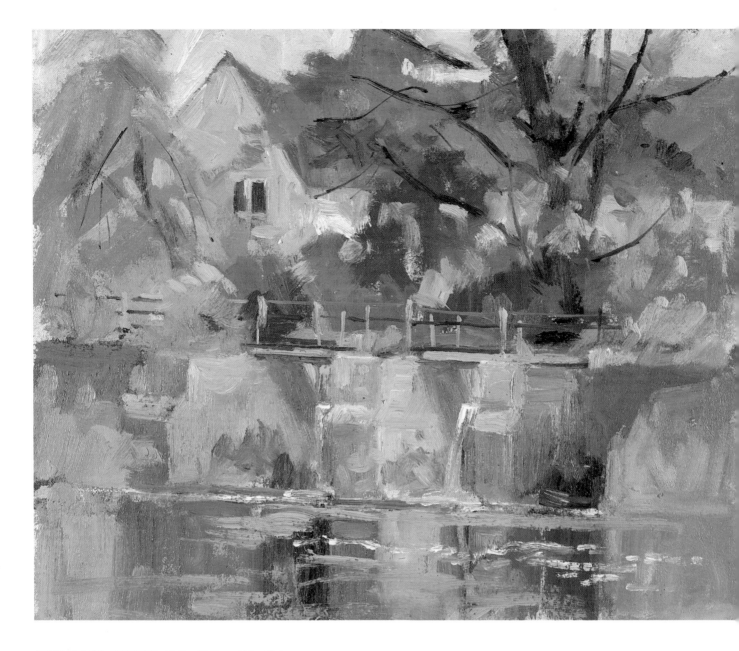

FIDDLEFORD, DORSET, 25.5 x 20.5cm (10 x 8in)

This outdoor painting shows a quiet corner of the River
Stour – a favourite place I could never tire of. The
illustration on page 47 is painted from the other side of
the bridge. I had previously stained the board with diluted
burnt sienna to provide a warm tone and my colours were
raw sienna, ultramarine, cadmium red, burnt sienna,
cadmium yellow pale and titanium white. Unfortunately the
day was dull with little contrast between the tone values
and the painting reflects it.

CHAPTER FIVE

Trees

Trees are one of the most joyous aspects of landscape painting. Their noble grace enhances even the simplest of subjects and plays an important part in composition.

Understanding their structural growth is essential. This is more practical in the winter months when all the leaves have fallen and colours are rich and strong in tone. Pencil or charcoal drawing is the best method of learning about trees. The essential element to look for when drawing is the sense of growth and rhythm of structure. This can be quite difficult because branches and twigs form a complicated mass. Aim to simplify what you see. Look for the overall shape of the silhouette first, noting differences between species.

My personal choice of medium for drawing trees is a soft grade graphite pencil. I have included some sketches to show techniques of rendering foliage.

There is only one way to learn how to paint or draw trees well and that is by working directly from nature. Of course you can work from a photograph, but unless you have the knowledge in the first place, your painting may lack conviction. Photographs of bare winter trees are more useful for reference than photographs of trees with massed foliage that conceals the structure underneath. Begin with single tree studies covering a variety of species.

Holding a piece of twig in your hand will acquaint you with the texture of wood and the way each section grows out from another in the same way as a tree does.

TREES IN THE LANDSCAPE

Drawing landscapes featuring trees is the next step forward from single studies; those drawings will be a source of reference for studio painting later on.

When you are drawing or painting trees, take particular notice of the colour of the trunk and branches. Trees are seldom the accepted conventional brown. Variable weather and age produce a wonderful grey-green patina. By the side of your monochrome winter studies, record the characteristic colours of each tree using written colour notes. Having completed a series of sketches you will then want to move from monochrome to colour. Limit the size of your first outdoor paintings to, say, 41 x 31cm (16 x 12in). A great deal can be learnt from painting trees outdoors in winter. Select simple tree compositions to begin with and then move on to more complex ones.

A range of tree species creates interest in a painting, but avoid too many varieties. Contrast slender trees with bulkier ones. Remember that

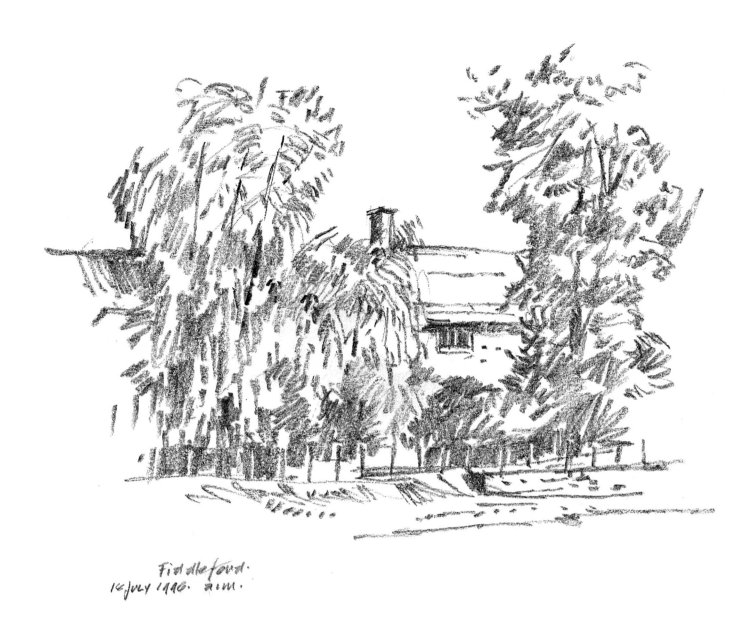

Fiddleford.
16 July 1996. a.m.

verticals are a powerful element of composition and
the overall balance of trunk, branches and foliage
should be considered.

Trees with an abundance of summer foliage are a
challenging subject. This is because the structure of
trunk and branch is not always visible and the leaf
mass lacks definition. Painting trees in full foliage is
more successful when the source of light is from one
side. Half-close your eyes to eliminate all the minor
half tones so you can concentrate on the principal
tones of light and dark. Don't try to paint each leaf
individually as this is laborious and a waste of time.

TREE SKETCH, 23 x 16cm (9 x 6 ½in)

One of my favourite pencils for outdoor sketching is a 2B
Koh-I-Noor Progresso carbon pencil which I have used for
this illustration. The beautiful weeping willow tree is
described with the minimum of detail but the difference in
character between it and the tree on the right is obvious.
The overall shape of a tree and its texture of leaf mass
should be determined before pencil is put to paper.

WINTER TREES, 15.5 x 12.5cm (6 x 5in)

In winter a familiar view can be transformed by a fall of
snow into an exciting subject. For this small oil painting
the colours I selected were cadmium red, alizarin,
ultramarine, raw sienna and titanium white. The painting
is on Canson Figueras linen textured paper.

STEP ONE
I roughly indicated the main shapes and angles of the
composition with diluted ultramarine. This makes it easier
to wipe out any mistakes.

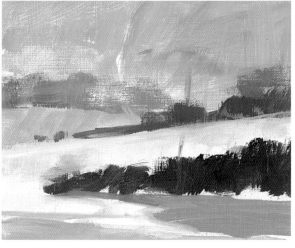

STEP TWO
The tone of the sky was established first. I blocked in the
foreground shrubs with ultramarine and alizarin. For the
hedge on the hill I mixed raw sienna, cadmium red and
white. At this point the tree was obliterated but as it would
be painted last it did not matter.

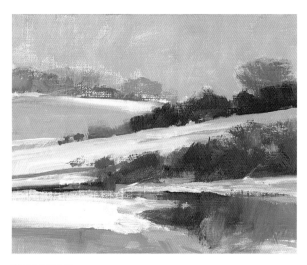

STEP THREE
To add warmth to the sky I painted into the blue with raw
sienna lightened with white. For the dark tone of the river
I mixed ultramarine and alizarin. Using artistic licence I
added a hill to the background and a streak of light to
increase the effect of recession.

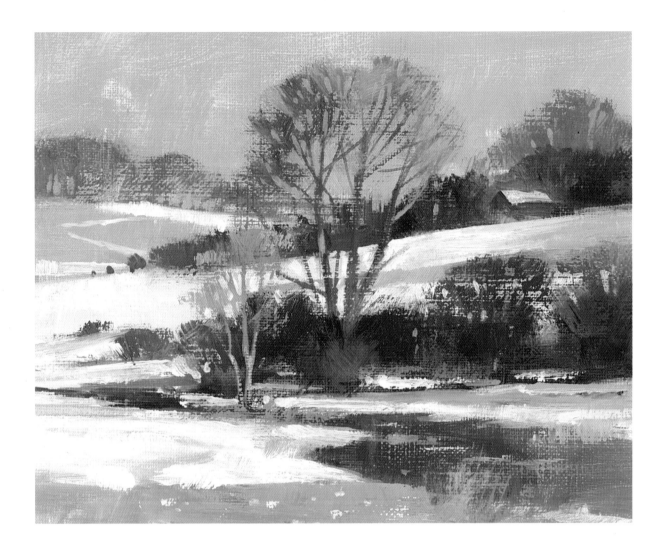

STEP FOUR

I decided to wipe out the left-hand part of the sky and repaint the whole area with cobalt blue, raw sienna and white, which looks better. The sapling in the sunlight is a strong contrast of tone and colour.

SUMMER TREES, 22 x 11.5cm (8 ½ x 4 ½in)

This outdoor sketch is an example of how pencil marks can be used to indicate the form and texture of leaf mass. Although summer foliage conceals the trunk and branches the willow is quite different in character and silhouette from the shape of the tree behind the barn roof. The old pantiled wall and foreground posts give some indication of height and a contrast of texture.

EARLY MORNING ON THE STOUR,

46 x 28cm (18 x 11in)

This studio painting is based on sketches of the countryside not far from my studio. My prime intention was to create a sense of aerial space and distance. I stained the acrylic primed board with burnt sienna which gave a warm ground to work on. The sky determines the mood of the landscape so that was painted first. Raw sienna and white were the colours mixed for the sky in the distance, and ultramarine, cadmium red, raw sienna and white for the remainder. I painted this part quite thinly, allowing the preliminary warm stain to show through.

After roughing in the landscape and water I was then able to add the trees. For the sapling foliage I mixed raw sienna, viridian, ultramarine and white. Ultramarine, cadmium red, raw sienna and white were the colours mixed for the trees on the right. This painting illustrates how the elegance of trees enhances the landscape.

SKETCHBOOK PAGE, 15.5 x 10.5cm (6 x 4in)

I have a great love of trees and draw them as often as possible. This sketch illustrates the character of elegant almond-leaved willows. When you draw a tree think of the fact that it is rooted into the earth; it is also alive and growing. Try to get the feeling of its structure.

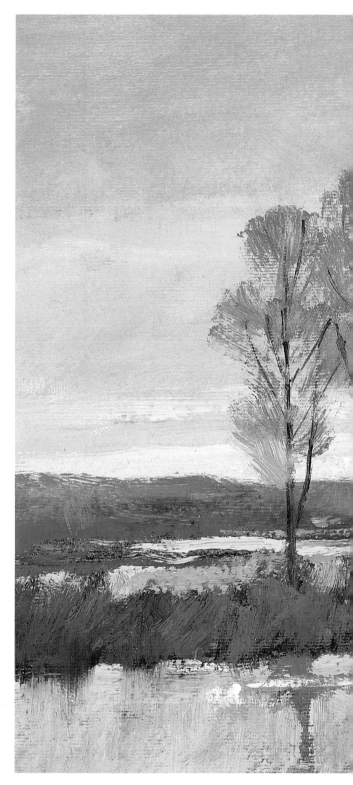

23 AVg/96 3:30pm. Fiddleford.

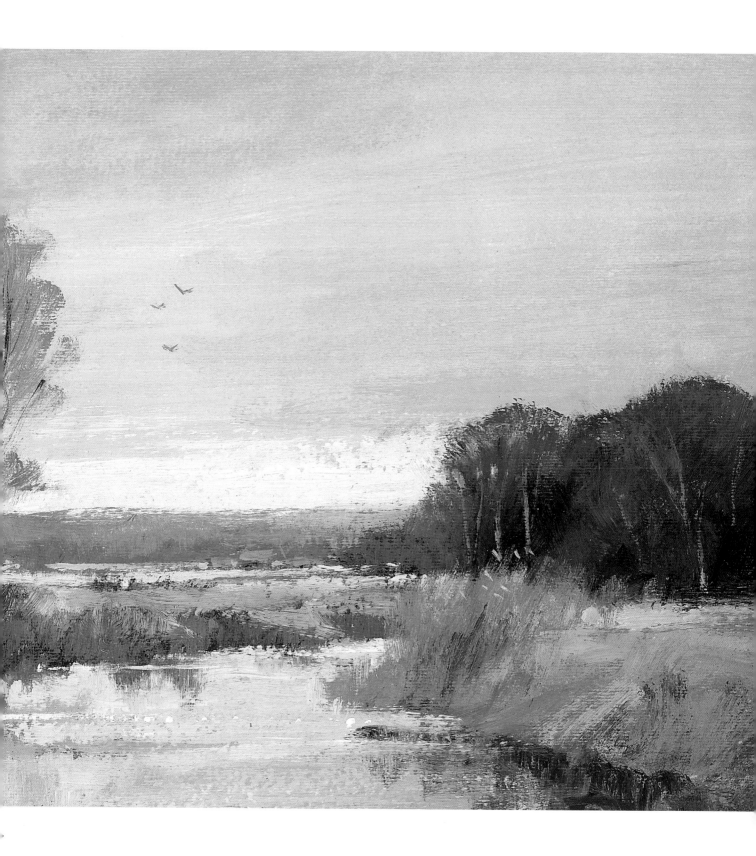

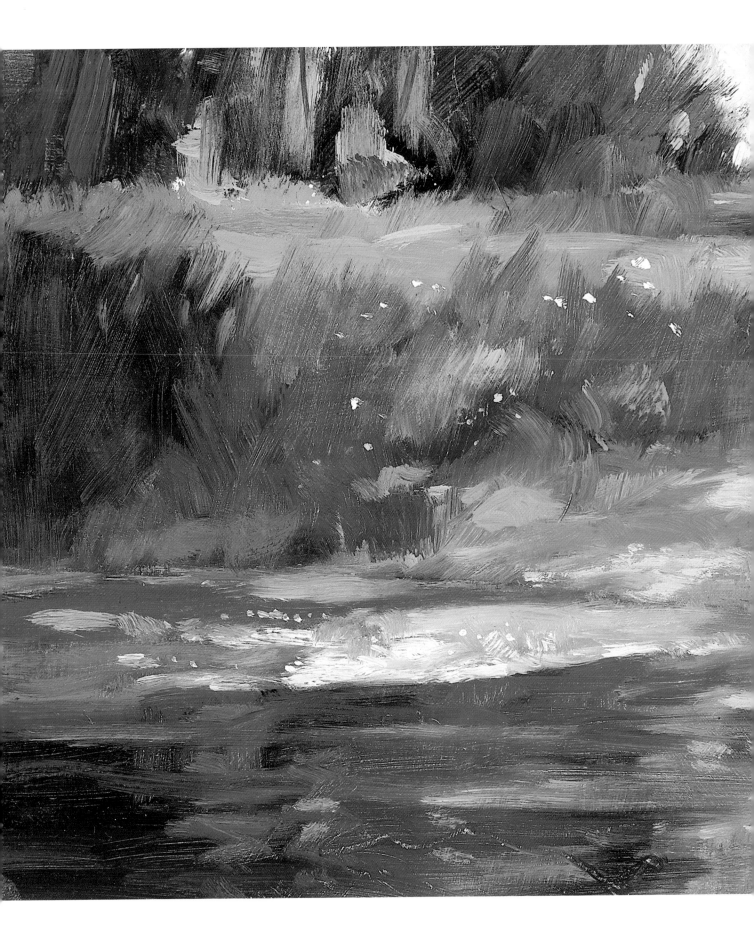

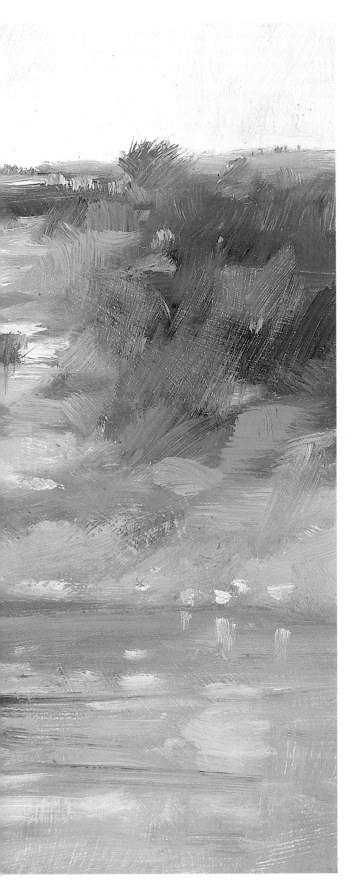

DORSET LANDSCAPE, 38 x 31cm (15 x 12in)

(Left) Trees occupy only a small part of this painting but if you try covering them up you can see how the mood of the subject changes. The rich dark tone is mixed from ultramarine, alizarin and burnt sienna. I softened the edges on the right while the paint was wet to avoid a hard-edged cut-out effect. This also helps to take interest into the far distance. The colours used were ultramarine, burnt sienna, raw sienna, alizarin, cadmium yellow pale and titanium white.

OUTDOOR SKETCH, 23 x 18cm (9 x 7in)

(Above) The trees in this scene were a confusing mass of summer foliage so I simplified shapes and suggested the character of leaves. By half closing your eyes, you can isolate principal forms which will help you to paint effectively and confidently rather than trying to re-create a subject in painstaking detail.

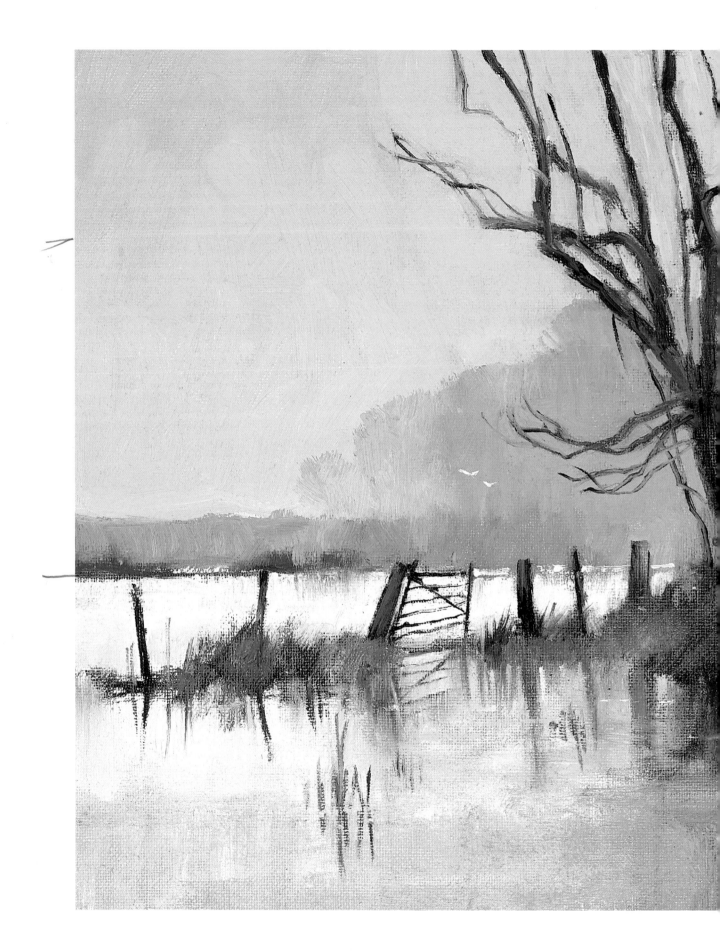

FLOODED FIELD, 38 x 31cm (15 x 12in)

(Left) It is unnecessary to include every branch and twig when you paint trees. The simplified tree in this painting adds to the wintry mood of the subject. For this painting I used only three colours: ultramarine, cadmium red and raw sienna with titanium white. For the sky I mixed ultramarine, cadmium red, a touch of raw sienna and white. Cadmium red, ultramarine and white were the colours used for the middle-distant silhouetted trees. Making sure the tone values are harmoniously balanced is the critical factor in this painting.

AUTUMN TREES, 25.5 x 20.5cm (10 x 8in)

(Below) After looking around the field for a subject for quite a time, I discovered this view along a path of autumn leaves. To add further recession I put in two extra poles in the distance. Before you start to paint trees, look for the rhythm of branches and overall shape.

For this outdoor oil painting the colours I selected were burnt sienna, yellow ochre, ultramarine, cadmium yellow pale and titanium white. The sky was painted first with a mixture of ultramarine, burnt sienna, a touch of yellow ochre and white. This gave me a background for the foliage of the trees. I ran out of time with this painting but rather than add work to it in the studio I decided to leave it as it was.

CHAPTER SIX

Buildings

Buildings are an integral part of the landscape and offer a huge choice of painting subjects ranging from city streets to isolated cottages on desolate moors.

A group of buildings may seem too difficult, so that you do not know where to start, but there is sure to be a section that attracts you more than the rest. Use your viewfinder to isolate the area and see how it can be made into a balanced composition.

You can build up a pattern of shapes and determine vanishing points by simplifying buildings into blocks. Establishing a low eye-level emphasizes the height and perspective of buildings by the acute angles of roofs, windows and door lines. To help you gain confidence, sketch in building lines lightly to start with. When the preliminary drawing looks about right, you can define them with a firmer line. Resist the temptation to tidy up your drawing by rubbing out because you will lose the effect of spontaneity.

It is just as important to indicate scale and distance with buildings as with an open landscape. Chimney pots, television aerials, windows, church towers or high-rise blocks establish a comparison of height, size and recession. Including figures, cars and street lamps also helps to give an immediate impression of scale and recession. Industrial subjects such as wharfside structures, gravel works and the

lunar landscape of quarries offer other exciting possibilities, and farms are another source of dwellings and outbuildings to investigate.

The best view of a village or town is often seen from its outskirts, where the buildings form an integral part of the landscape. Focusing on part of this scene may produce a more interesting subject than attempting a wider view.

Light shining through a window at dawn or dusk is a subject I occasionally like to paint. To me it not only indicates the presence of people but also creates a sense of stillness, peace and solitude.

Making individual studies of buildings means that you can amass a whole range of material to use for reference. Permission to paint or draw must always be requested before entering either an industrial site or the grounds of private property with public access.

Street scenes offer a great opportunity for a wide variety of subjects. Architectural styles vary from county to county, from picturesque thatched cottages and simple stone dwellings to the grand opulence of civic buildings. Rural churches or the grandeur of cathedrals viewed from a distance provide a focal point in many paintings and are an endless source of potential subjects.

Sunlight and shadow emphasize the structure of buildings. Establishing the pattern and angles of cast

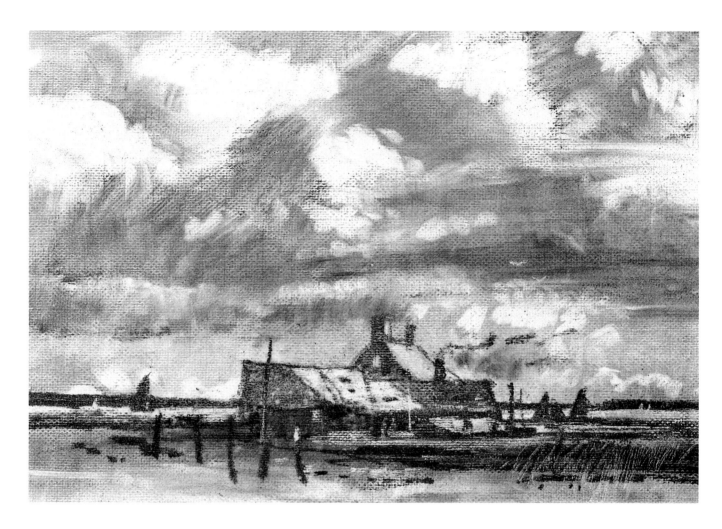

shadows first and ignoring subsequent changes of light and shade is a practical approach to avoid constant alterations to your painting.

Your paintings of buildings need not just be confined to rural scenes. The view from an upstairs window, for example, offers many possibilities. One of my earliest commissions was to paint a picture of a London power station viewed over the rooftops from a second-floor window in Wandsworth. The pattern of angles and verticals in the urban landscape was interspersed with patches of colourful washing which made a wonderful and dramatic composition. The restoration of Chichester Cathedral under scaffolding was another exciting challenge in perspective. Determining the angles of rooftops, windows and doors is not always easy. To overcome this problem, hold a pencil or brush horizontally across your eyes. This establishes your eye-level, so

ESTUARY, 19.5 x 12.5cm (7 x 5in)

This group of boat sheds and a house forms a compact arrangement of pleasing shapes in an open landscape beneath a big sky. The effects of sunlight and shadow give dimension and form to the buildings. My charcoal sketch is on fine linen textured paper, and I used the technique of lifting out the lightest parts with a putty rubber. The paper is primarily for oils or acrylics but it also has possibilities for sketching. I like the composition of this subject, particularly the opposing angles of the buildings and emphasis on horizontals.

that you can judge at which angle the lines go up or down. Remember that parallel lines going into the distance appear to become closer together and converge at a point on the horizon.

PERSPECTIVE STRUCTURE

It is easier to draw a building in perspective if it is placed in a box. If the perspective of the box is right, the building will be right too. Drawing a box at different angles above and below eye-level is excellent practice.

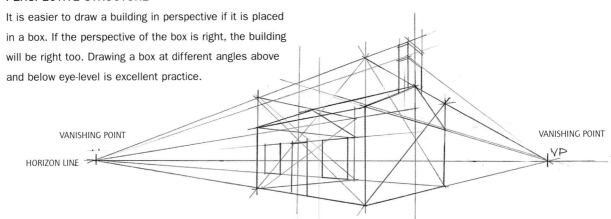

VANISHING POINT

VANISHING POINT

HORIZON LINE

VP

DORSET COTTAGES, 25.5 x 20.5cm (10 x 8in)

The furrows in the field of this outdoor oil sketch illustrate the principle that parallel lines appear closer together as they recede. The colours I used for this painting were burnt sienna, alizarin, yellow ochre, cadmium yellow pale, ultramarine and titanium white. Old buildings like these cottages form an integral part of the landscape.

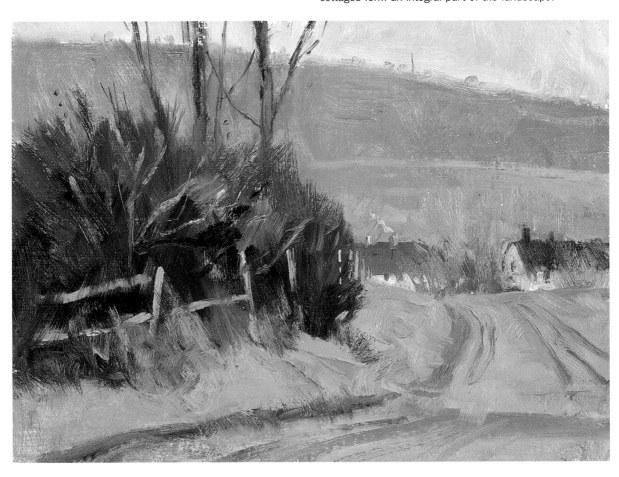

BARNS, 17 x 10cm (7 x 4in)

It was a dull day when I did the top line drawing of a group of delightful old farm buildings I came across in Cornwall. The texture of stone walls and pantiled roofs made a wonderful subject, with the potential for a painting. Back in the studio I made a second sketch to illustrate how a subject comes to life through an effect of light and shadow. This is only one effect; and there are many more alternatives to try.

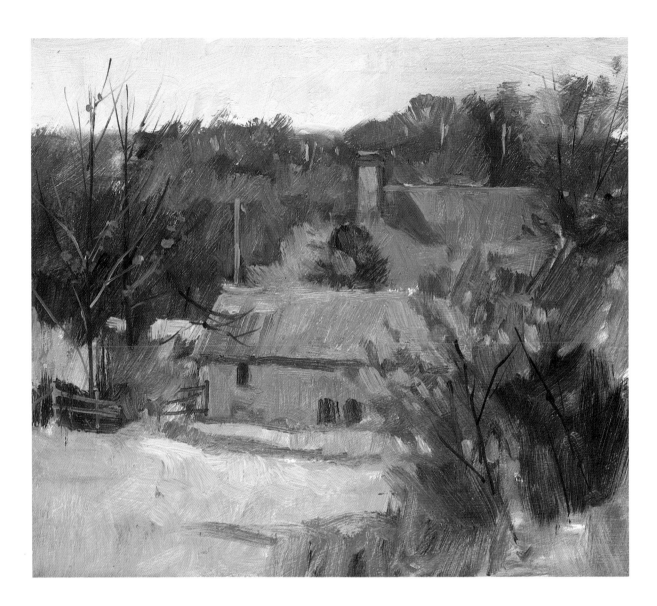

FARMHOUSE, 25.5 x 20.5cm (10 x 8in)

We can learn a lot from the simplest of subjects. This
outdoor oil sketch may have little merit but it is direct and
has a quality of light. I was attracted to this subject by the
orange-coloured roof and the contrasts of tone against a
pale sky. The colours used were ultramarine, cadmium
yellow pale, cadmium orange, burnt sienna, raw sienna
and titanium white.

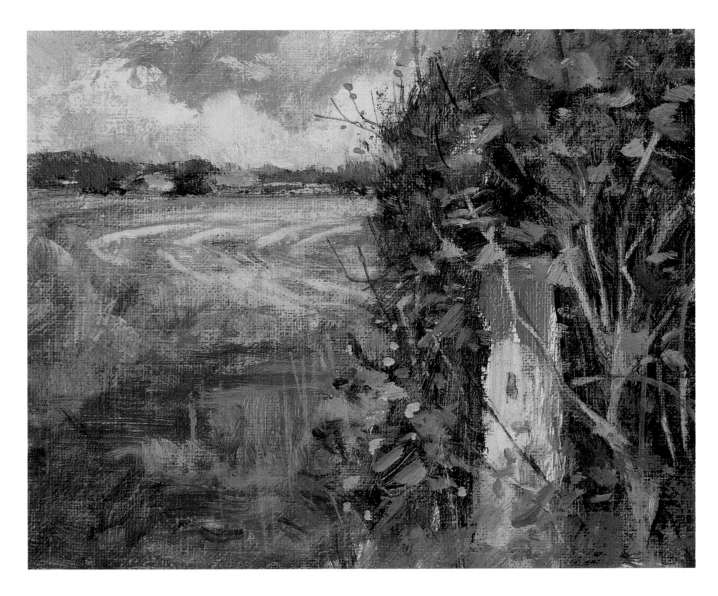

DORSET FIELD, 20.5 x 15.5cm (8 x 6in)

Although expressed simply in patches of colour, the buildings in the distance give a sense of scale and recession in this small painting. All colour becomes greyed with the atmosphere of distance. I added the slightest touch of grey to the tan-coloured roof to achieve that effect. The painting is on fine linen canvas and I retained the delightful texture as much as possible.

My palette for this painting was cobalt blue deep, burnt sienna, raw sienna, cadmium yellow, cadmium red and titanium white.

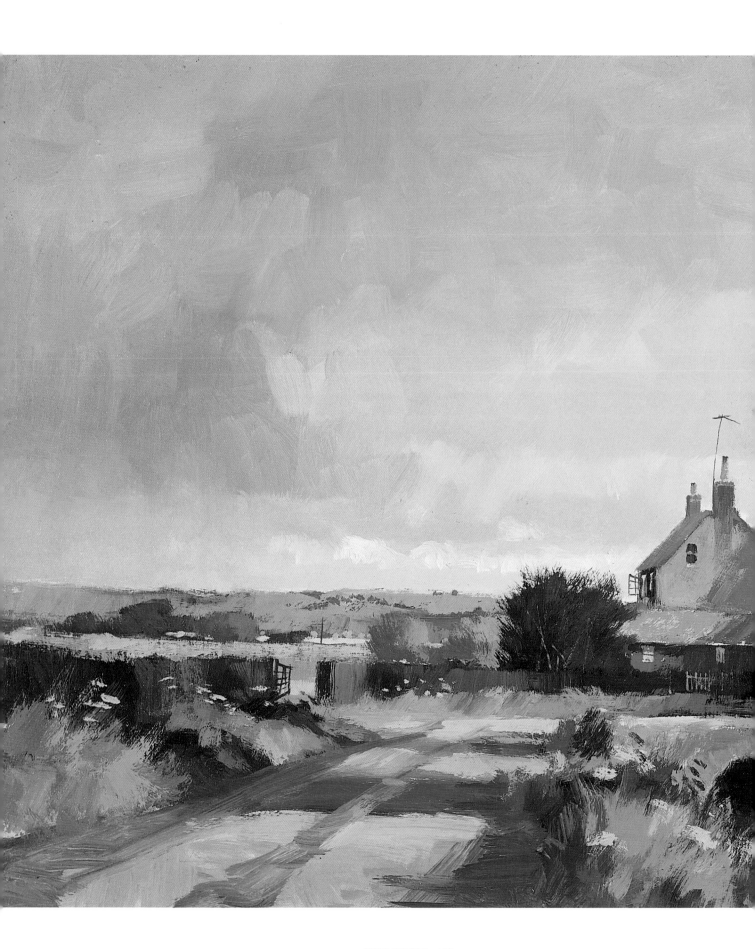

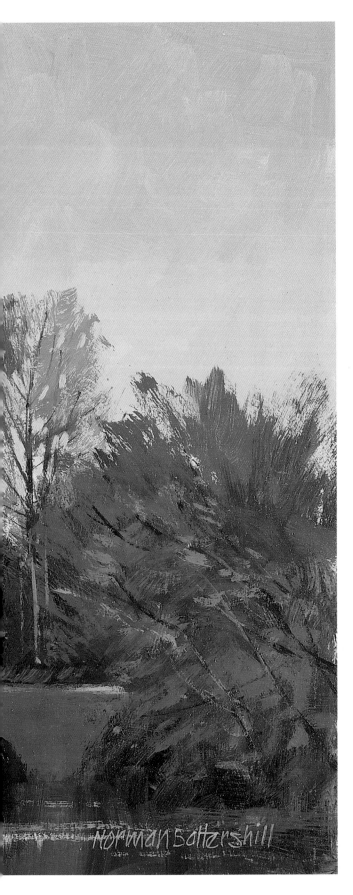

BRIDGE COTTAGE, 62 x 46cm (24 x 18in)

The emphasis in this composition is on the right, but balance is provided by shadows on the left across the lane. Any buildings featured in a landscape must be an integral part of the scene not simply stuck on the ground. The positioning of buildings is also important. To take interest into the painting the cottage here is angled inwards. These seemingly minor considerations have a part in the concept of a successful composition.

The colours I used were ultramarine, burnt sienna, cadmium yellow, cadmium red and titanium white.

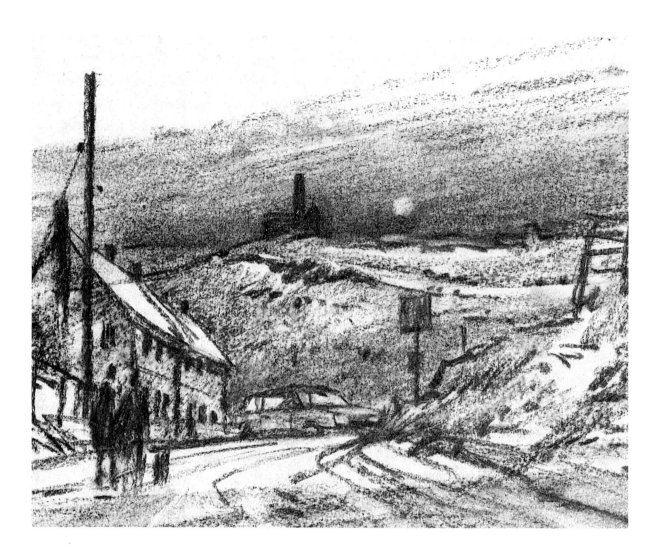

TIN MINE, CORNWALL, 20.5 x 10cm (8 x 4in)

Buildings do not necessarily have to occupy a lot of space
in a drawing or painting, as my charcoal sketch illustrates,
but they can still be the focal point and feature. The
steepness of the hill in the middle distance is suggested
by the acute perspective of the building roofline and
approaching car. This increases the dramatic effect of
silhouetted buildings high on the skyline.

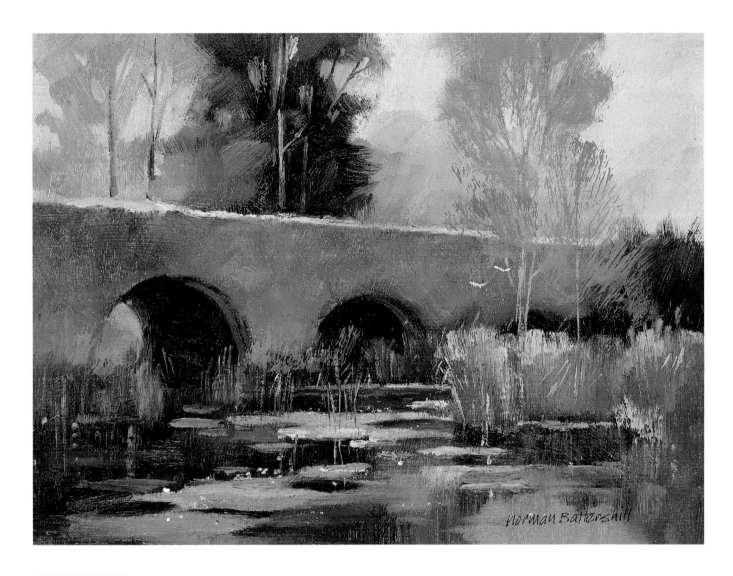

DORSET BRIDGE, 38 x 31cm (15 x 12in)

Bridges can be as much an integral part of the landscape as buildings. With such a diversity of style and material, there is wonderful scope for bridge paintings. Bear in mind that when painting a structure such as a building or bridge, a three-quarter angle has more interest than a flat elevation. The angle of this bridge leads interest into the painting.

To suggest a patina of weathering and texture on the bridge I first of all applied a stain of burnt sienna. When it had dried I painted over it a warm grey mixed from ultramarine, burnt sienna, cadmium yellow and titanium white. The arches are the same colour as the dark tree. Ultramarine, burnt sienna and cadmium red without any white are the colours I used for these areas. The bridge is the main subject and I also wanted to capture an element of light and atmosphere.

The colours on my palette were cadmium green, ultramarine, burnt sienna, cadmium yellow, cadmium red and titanium white.

Coastline Subjects

Along the coastline there are limitless opportunities for the artist. Coastal towns and villages have a magical atmosphere which is quite different from inland towns. The silver quality of light is often the reason why artists are attracted to living in coastal regions. On a bright sunny day the light in the sky becomes more luminous as you near the coast. This is caused by the reflection of sunlight from the sea which acts like a mirror.

The sea as a subject in a landscape painting opens up possibilities for a whole range of subjects. Sand dunes and cliffs, pebble beaches, intimate coves, stretches of sand and rock pools are all to be found along a coastline. When painting these subjects look for the opportunity to give a feeling of scale. A cliff rising above a beach, for example, may have a feature such as a dwelling or a mast that will give a sense of height to the subject. Figures and beached boats can also give scale and the illusion of recession to your painting.

Seascape skies appear different from inland skies because the light reflected off the sea has an influence on the colours and misty substance of the clouds. Next time you are on the coast observe the sky over the sea and compare this by turning around and looking at the atmosphere and light of the inland sky.

Seaside resorts are rich in architectural styles, ranging from grand hotels to elegant piers still bearing the mark of Victorian decorative skills. Sadly, though, many have disappeared, badly damaged by fire or storm or disintegrated with the passing of time.

Sitting on a beach sketching a pier is something I have enjoyed many times. In some cases, the complex latticework structure of iron girders supporting a wooden platform stretching out to sea dates right back to Queen Victoria's reign. By contrast the simple stone jetties and harbours of many fishing villages along the coastline have a more intimate and rugged appeal.

Painting a canvas on a deserted Cornwall beach in midwinter in a wind that made my ears ache was one of my most exhilarating experiences. Provided you remember to wrap up well against the weather, opportunities to capture the atmosphere and moods of winter on the coast should not be missed.

In these conditions it is more practical to produce a small painting which is easier to secure and quicker to finish.

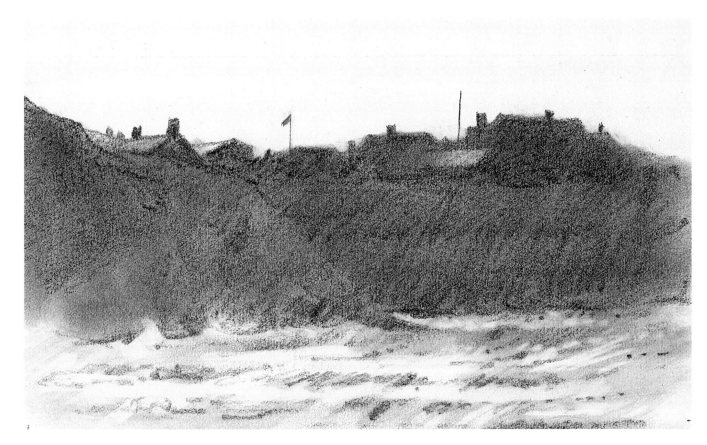

MORNING LIGHT, NEAR CRANTOCK, CORNWALL,
21 x 11.5cm (8 x 4in)

These clifftop buildings form a fascinating silhouette with
roofs blending into half-light adding atmosphere and a
subtle contrast of light against dark. First of all I
sketched in the silhouette of the buildings and shaded
the area with a 6B pencil, then smudged it with kitchen
tissue to produce a flat tone.

 The same technique was used for the sea and I then
proceeded to lift out touches of light with a putty rubber.
I was pleased with the result of this small sketch which
could easily form the basis for a large impressive
painting.

THE LIZARD, CORNWALL
20 x 17.5cm (8 x 7in)

I expect this delightful jumble of shacks has been
smartened up since I did this outdoor conté sketch a
while ago on a painting trip to Cornwall. Looking down
from a high viewpoint makes an interesting subject.

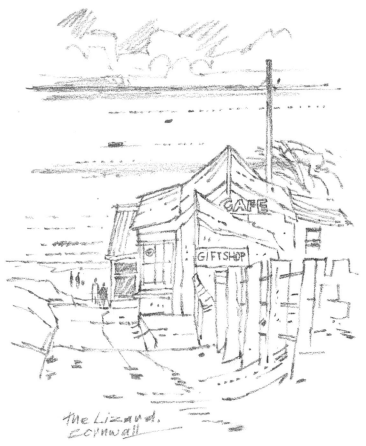

NEAR THE LIZARD, CORNWALL,

15.5 x 12.5cm (6 x 5in)

For this demonstration I have reconstructed the step-by-step development of my small oil sketch. The colours used were viridian, raw sienna, cobalt blue, alizarin and titanium white.

STEP ONE

I roughed in the basic composition with a 2B pencil, and established a general colour scheme. I decided to leave the sky until last so I could judge colour and tone more easily.

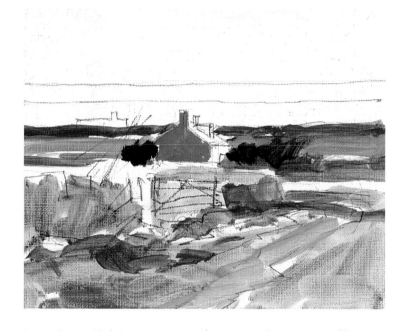

STEP TWO

For the sunlit field I mixed viridian, raw sienna and white. You can see that the contrast of light and dark tones begins to take shape at this stage.

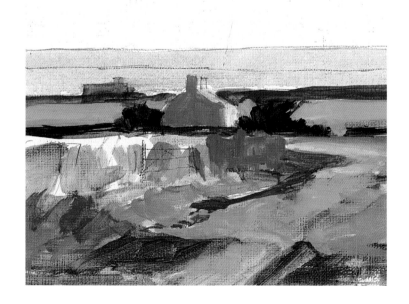

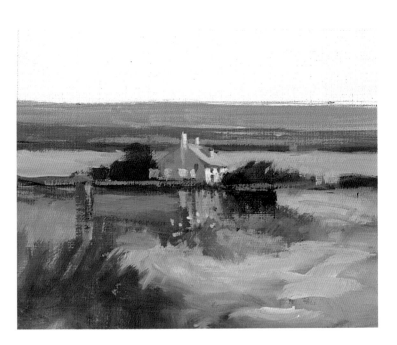

STEP THREE

I decided that the distant cottage was unnecessary and simplified the composition by deleting it. I then softened the wall shadow and put in another field beyond the hedge in order to add recession. I used cobalt blue and raw sienna for the sea.

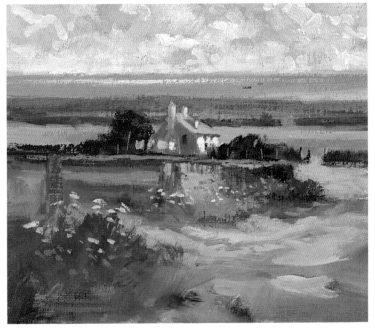

STEP FOUR

The sky colour was produced from a mix of cobalt blue, raw sienna plus white. This was also painted over the sea, harmonizing the two areas. As with the cottage, I felt that the gate did not really add to the scene so I deleted it in the final stages of my oil sketch.

Portland Quarry

The scope for coastal subjects is endless. The illustration below is the Wheal Coates engine house at Chapel Porth. Although the climb to reach it is steep, the view is absolutely breathtaking. The physical labour of the proud Cornishmen who sank shafts through rock and burrowed under the sea for tin and copper is remarkable. For these sketches I used a graphite pencil on grey sugar paper.

Dorset Coastline

Tin Mine, Cornwall

Incoming Tide

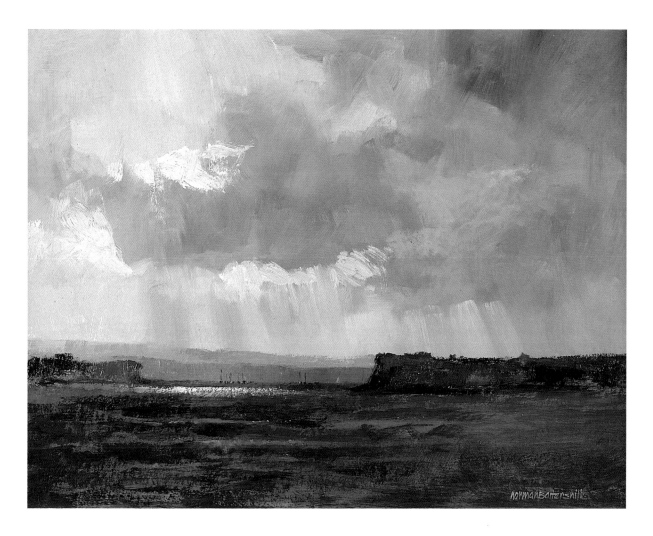

OCTOBER LIGHT, POOLE HARBOUR,
58.5 x 46cm (23 x 18in)

A big dramatic sky with pale shafts of sunlight and a leaden sea gave me the opportunity for this studio painting. Before I began painting I applied a stain of burnt sienna to the sky area and burnt umber to the water. This made it easier to judge tone values and also gave me a warm ground to work on. To achieve the effect of rays of sunlight I painted wet into wet and blended the edges.

My palette was limited to a few colours: burnt umber, ultramarine, raw sienna and titanium white. I particularly liked the way the subject was divided into simple planes of warm subtle tones. It was tempting to include a white sail caught in the sunlight but instead I added a sail in shadow on the right towards the horizon. There were many more sailing boats in the harbour but I deleted a lot of them to focus on the middle distance patch of sunlight.

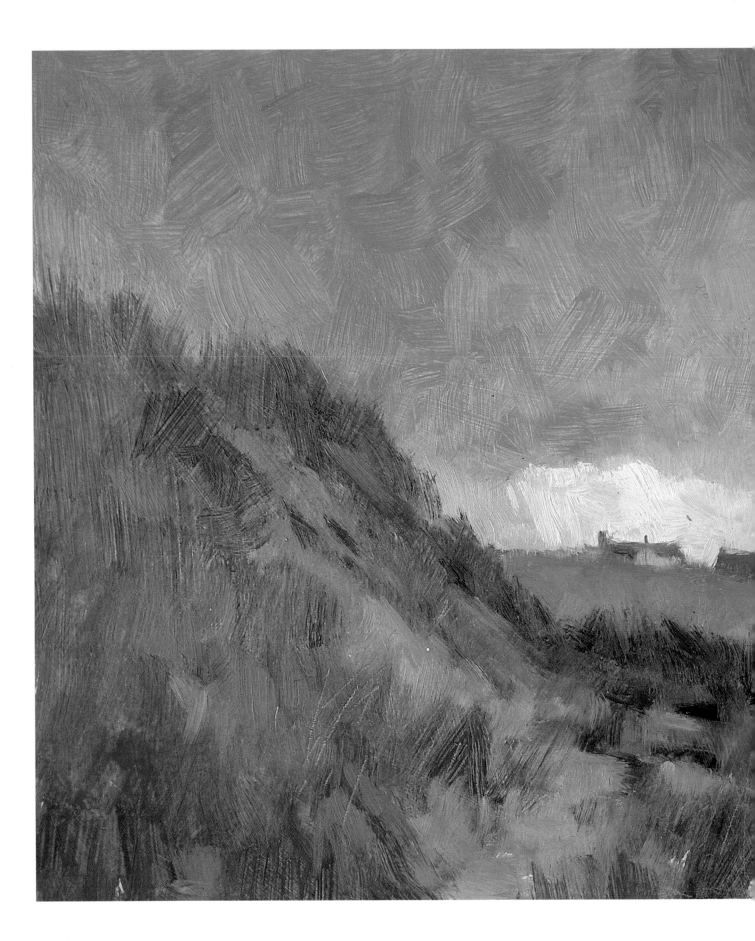

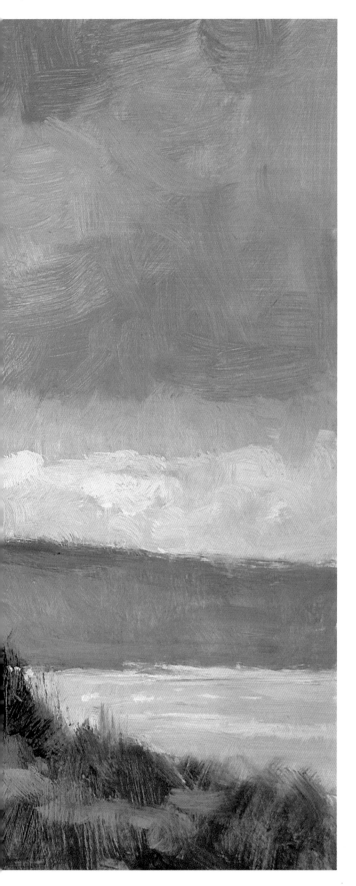

CRANTOCK, CORNWALL, 41 x 30.5cm (16 x 12in)

It was threatening to rain but I could not resist trying to capture the atmosphere of this dramatic scene. Under these circumstances it is always best to assume your time is limited. Go for the essential pattern of shapes and contrast of dark and light tones. Don't worry about detail and keep your brush moving. Limiting your colours simplifies mixing and saves time. I finally got rained off but at least I had achieved something.

PULPIT ROCK, PORTLAND, DORSET,

18 x 13cm (7 x 5in)

Quarries and a rugged coastline feature in this stark and fascinating island. I had a stone cottage and a studio there for several years. The ear-splitting boom of the foghorn from the Portland Bill lighthouse is a sound I can never forget. The subject of my sketch, Pulpit Rock, is near the lighthouse. The

adventurous climb the slab to stand on top of the rock.

I have endeavoured to illustrate the sculptural quality and solidity, and the perpetual movement of the sea around it. I used a Rexel Derwent Charcoal pencil (dark) on cartridge paper.

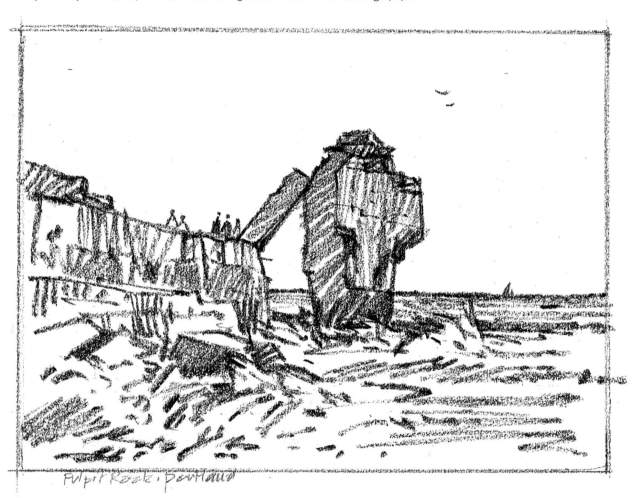

Pulpit Rock, Portland

INCOMING TIDE, CORNWALL, 31 x 25.5cm (12 x 10in)

(Right) Like many artists I have a great love of the sea. One of my most memorable painting trips to Cornwall was to stay in an old coastguard's cottage. Summer had long gone but I painted every day on the beach, thrilled and exhilarated by the rough seas and wild weather.

The colours I used for this painting were ultramarine, alizarin, burnt sienna, raw sienna, viridian, cadmium red and titanium white. The basic colours for the sea and rocks were viridian, burnt sienna, raw sienna and ultramarine. For the darkest colours of the rocks I mixed ultramarine and alizarin.

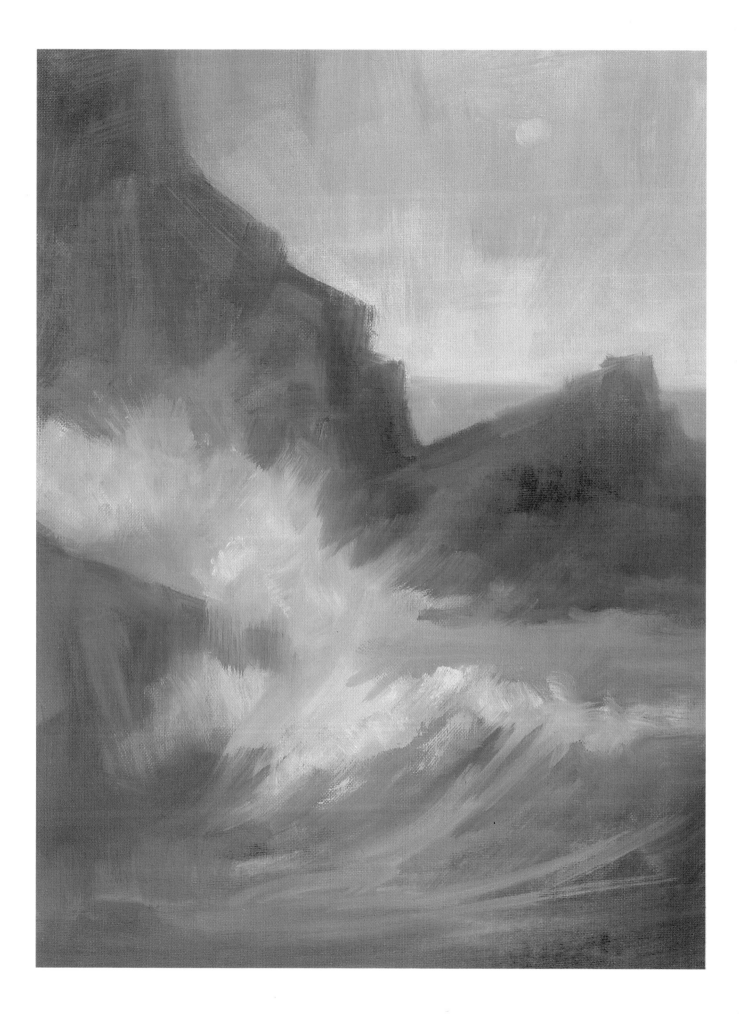

Expressing Moods of Nature

Expressing the moods of nature is not only confined to the atmospheric effects of weather but also to capturing a sense of time and place. A studio landscape painting with this quality has distinction and indicates that the artist has gathered his knowledge by consistent outdoor work.

There is more to painting and sketching outdoors than some artists may realize. At the same time you should be aware of your surrounding environment and a sense of time, place and atmosphere. When painting a landscape in the studio, the memory of those moments and your creative ability will help contribute to the chance of success.

Remember that the mood in landscapes is determined by the effect of the light from the sky. Adverse weather conditions such as rain, mist or snow can add to the dramatic effects of mood and atmosphere. Having the experience of painting or drawing outdoors in different weather conditions is an invaluable asset to the landscape painter.

A memorable experience was a painting I did in swirling fog among a flock of sheep. A lasting impression of the eerie stillness and the fluctuating images of trees and sheep remains locked away in my memory. No landscape painter can make significant progress without actually experiencing the varied and wonderful effects of nature's many moods.

Dawn and dusk can produce the most magical moments of beauty which are difficult to capture on canvas. Rich, colourful sunsets, for example, can often look better in reality than in a painting.

SUSSEX LANDSCAPE,
23 X 16cm (9 x 6in)

Charcoal is an ideal drawing medium to express fleeting moments of light and shadow.

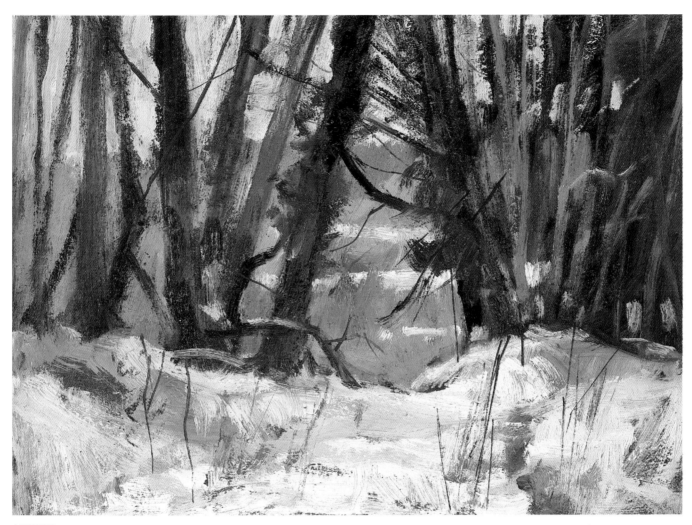

WINTER, 25.5 x 20.5 cm (10 x 8 in)

This was one of my most enjoyable outdoor winter
paintings. The trees in the distance were evergreen but I
changed the colour to create atmosphere and recession.
The colours I used were ultramarine, cadmium red, burnt
sienna, yellow ochre and titanium white.

To demonstrate how the moods of nature can transform a subject I have painted similar scenes in different weather conditions. The subjects are imaginary.

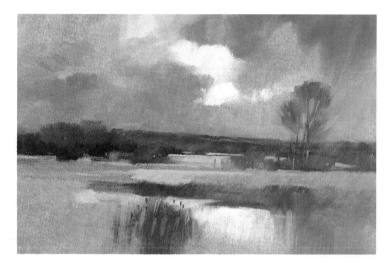

RAIN CLOUD, 28 x 19.5cm (11 x 7½in)

Following my usual method I established the tone of the sky first. Next I painted the distant hills mixed from ultramarine, cadmium red and a touch of white. For the dark hills I mixed ultramarine, cadmium red, burnt sienna and titanium white, while raw sienna, cadmium yellow pale, viridian and white were used for the fields.

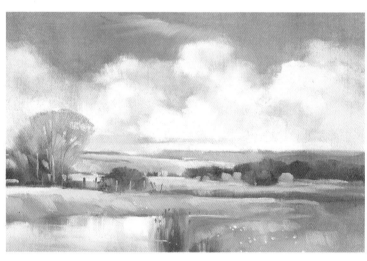

SUMMER FIELDS, 28 x 19.5cm (11 x 7½in)

For a fresh clear sky I used cobalt blue. The sky was laid in first but the final touches were left until last. At the height of summer, green is the predominant colour. For this painting I mixed raw sienna, cadmium yellow pale, cobalt blue, cadmium red and titanium white.

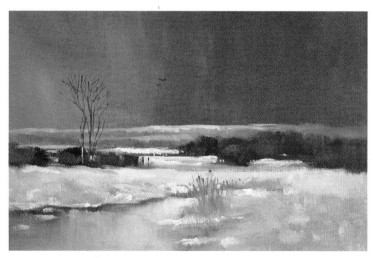

SILENT LANDSCAPE, 28 x 19.5cm (11 x 7in)

The sky is a mix of indigo, burnt sienna and white. For the snow I used cerulean, cobalt blue and alizarin plus white. Ultramarine, alizarin, burnt sienna and cadmium red were the colours mixed for the middle-distance trees.

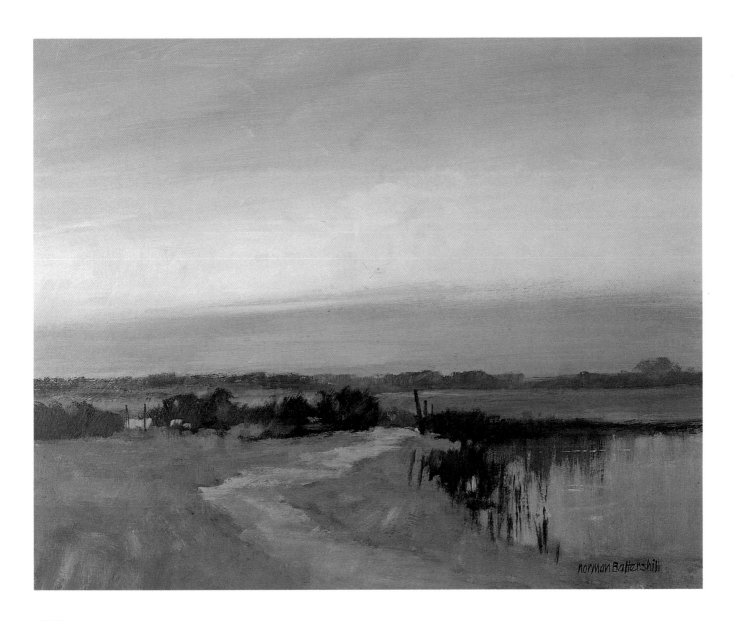

DUSK, 25.5 x 20.5cm (10 x 8in)

The theme for this painting is peace and stillness. Still
reflections and a low tonal key contribute to the effect of
tranquillity. My colours were cobalt blue deep, alizarin, raw
sienna, viridian and titanium white.

DUSK, 19 x 12.5cm (7 x 5in)

I have spent many hours painting and drawing in the meadows along the banks of this stream and this painting is based on sketches I did there. I began with raw sienna loosely brushed across the sky and then wiped with a clean rag. The result is a clear transparent stain over which I painted the cloud.

For this colour I mixed raw sienna, burnt sienna, ultramarine and titanium white. For the trees I added alizarin to my palette and mixed it with ultramarine. The river bank is raw sienna, ultramarine, alizarin and titanium white.

I painted on fine linen-textured Canson Figueras. While the paint was wet I scratched out the highlights on the water and the moon. Developing an atmospheric painting from the imagination is exciting and a great challenge.

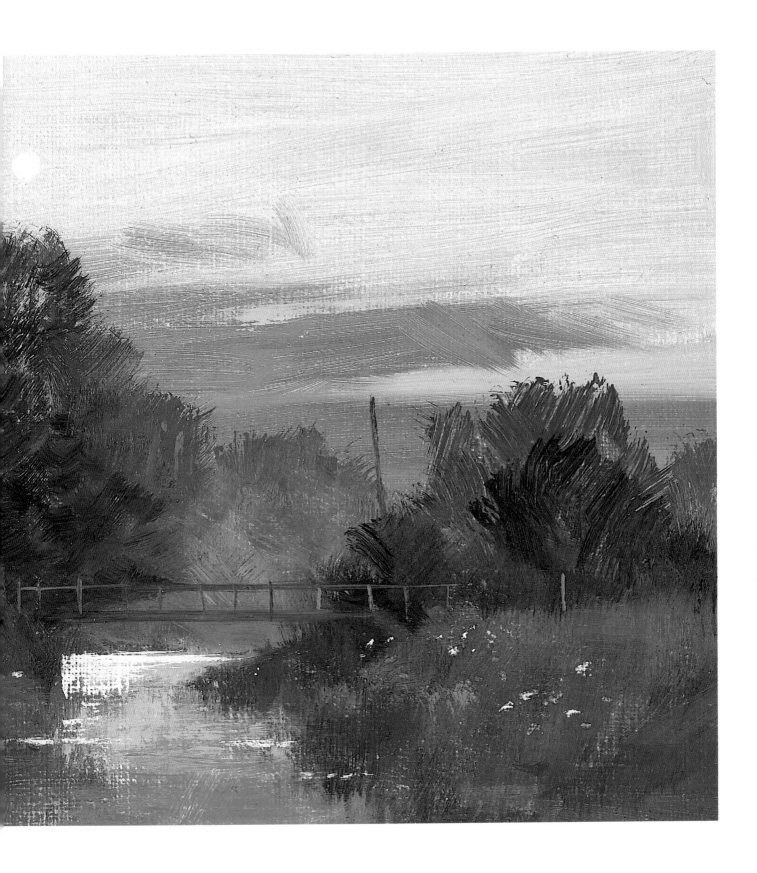

SUMMER FIELDS, 31 x 20.5cm (12 x 8in)

A cornfield and poppies under a summer sky with a heat haze on the horizon provided the idea for this imaginary landscape scene.

Raw sienna was rubbed in for the sky and then the heat haze was mixed from ultramarine and alizarin. I wiped out the disc of the sun with a clean rag while the paint was wet.

Linking one part to another is an important element of a harmonious composition. Here, the trees in the foreground join up with the horizon, taking interest into the distance. The poppies also create a link leading from the foreground to the cornfield.

My palette also consisted of crimson, cadmium yellow and titanium white.

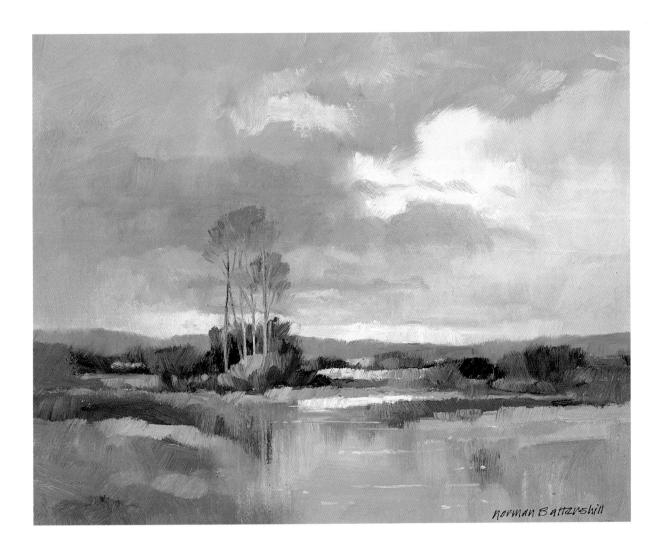

LIGHT AND SHADOW, 46 x 38cm (18 x 15in)

For this painting I incorporated the principal elements
of landscape – sky, trees, fields and water – into a scene
of tranquillity and aerial atmosphere. First, the sky was
roughed in to determine direction of light and contrast
of dark and light clouds. The key to this painting is the
line of distant hills. Every colour and tone is judged
against the deep, rich colour. To ensure crisp, clean
colours I mixed no more than three together, sometimes
only two. The subject is imaginary and, for me, it typifies
a perfect English landscape.

My colours were ultramarine, alizarin, burnt sienna,
cadmium yellow pale, yellow ochre and titanium white.

DAISY PATCH, 20.5 x 15.5cm (8 x 6in)

(Right) I came across this patch of daisies in the corner of
a field. Half in shadow, half in light, it was such a simple
but beautiful subject that I was immediately attracted to it.
The board had already been stained with burnt sienna
which gave a warm tone on which to build the painting.

Trees in the background were dense but I opened them
up by showing patches of sky. When you paint trees,
remember to let the birds fly through.

My colours were viridian, cadmium yellow pale, burnt
sienna, cadmium red, raw sienna, ultramarine and
titanium white.

RAIN, 9 x 7cm (3 x 2in)

(Above) A thin stick of charcoal and a piece of paper is all
you need to have fun producing imaginary landscapes and
moods of nature. This tiny sketch is an example.

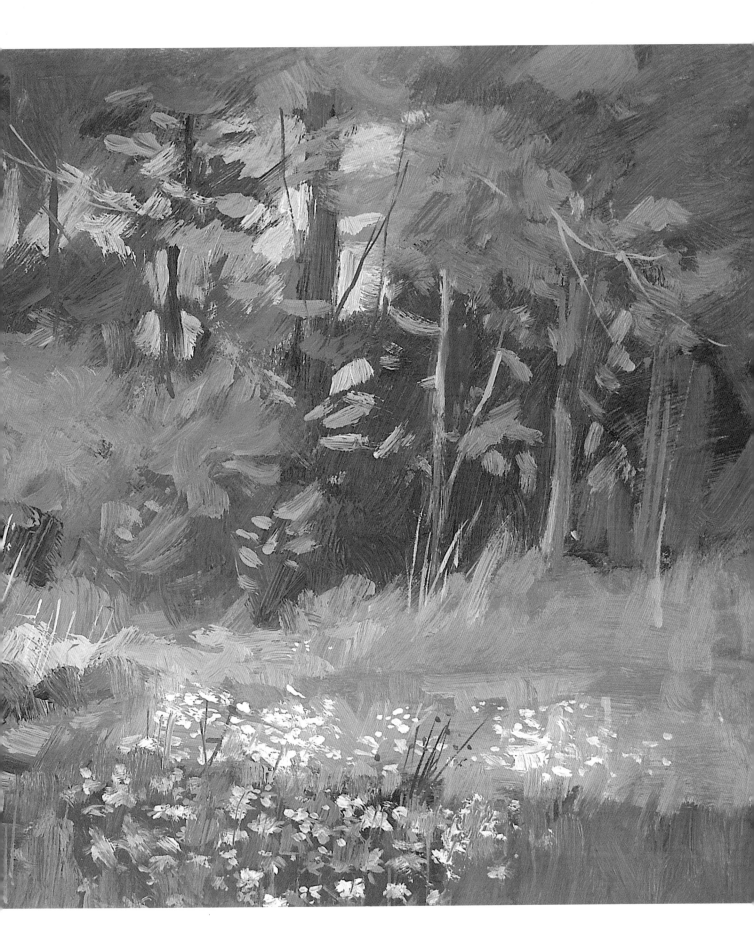

CHAPTER NINE

Painting Landscapes in the Studio

PAINTING FROM SKETCHES

I usually draw in line without colour note references for my outdoor sketches. Once in the studio, roughing in a painting from a sketch is often enough to trigger a recollection of time and place. Enlarging a small sketch into a painting, however, means considering the composition more carefully. It is easy to lose the intimacy of the small original by enlarging it. To keep the same scale, you can use the technique of squaring up the original and transferring the image to a proportionate enlargement. You can also rearrange some of the basic elements of the sketch (or sketches) to produce a totally different subject. Painting from sketches has the advantage of allowing the memory to filter out minor aspects of the subject, thus eliminating unnecessary detail which can make your painting look fussy and overworked.

Tonal sketches are useful references for studio painting. John Constable used this method extensively for his rural masterpieces which he created in his London studio. Alternatively, a line sketch done outdoors can have its tonal scheme worked out in the studio. This is the method that I tend to use to develop my outdoor linear sketches into a studio painting. I often experiment with several tonal schemes to determine the effect I want to achieve. Another method is to develop an

outdoor colour sketch (in any medium) into a studio oil painting.

WORKING FROM PHOTOGRAPHS

There is no reason to disapprove of the artist who works from photographs. They can provide an excellent source of reference when circumstances make it impractical for the artist to stand and paint a particular subject.

It is, however, unwise to faithfully copy a photograph. This may be tempting but will only result in an uninspired example of technical skill or simply a bad copy.

A photograph will often trigger an idea for a painting. By changing the colour scheme or atmosphere, new possibilities can be created. You can also experiment with making sketches from a photograph and imagining that you are drawing the scene from life. Working from your own photographs is preferable because they are obviously more personal.

You can transfer the proportion of a print to a larger size by drawing a diagonal line from the lower left-hand corner to the top right-hand corner and continuing it on to your canvas (see page 98). Creating a painting in colour from a black and white

PAINTING LANDSCAPES IN THE STUDIO **94**

photograph is an excellent way of learning all about tonal values. Select only the main contrasts, as you do when painting outdoors.

If you are stuck for ideas for a subject to paint, think of a title for a picture to express a sense of atmosphere, such as 'Evening Star' or 'Daybreak'. Write out a list of ideas as they come to you and select one that inspires you. Concentrate on the theme and try it out with some preliminary sketches as a prelude to painting.

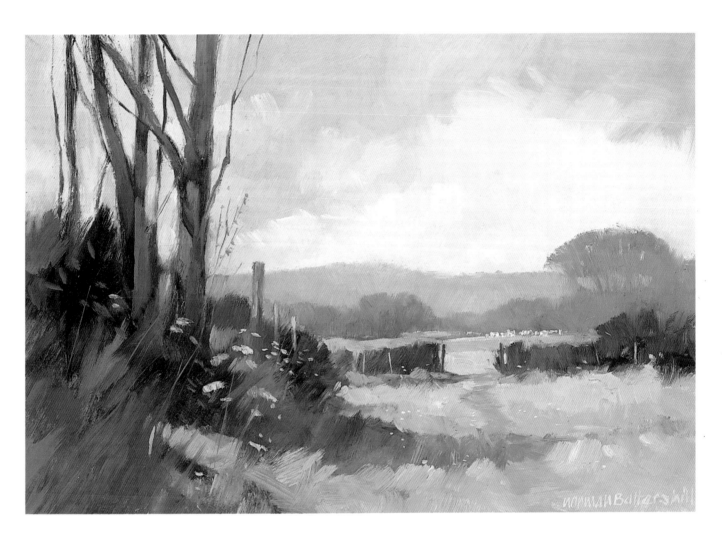

SUMMER MEADOWS, 41 x 30.5cm (16 x 12in)

This studio painting was an exercise in expressing the light and atmosphere of high summer. Detail is kept to the minimum with the emphasis on broad areas of clean fresh colour. The colours used were burnt sienna, ultramarine, cadmium red, cadmium yellow pale and titanium white.

AFTER THE RAIN, 15.5 x 12.5cm (6 x 5in)

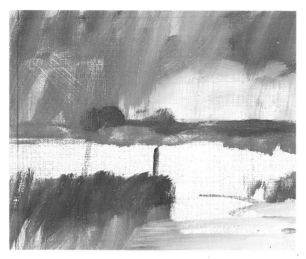

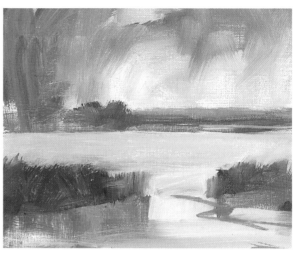

STEP ONE

The Figueras canvas-textured paper I used was commercially acrylic primed, but I added a further coat of acrylic gesso primer. I selected a colour scheme of ultramarine, burnt umber, raw sienna, cadmium red and titanium white for this painting. I began by roughing in the basic outlines and establishing the sky.

STEP TWO

I was now able to judge the general tone of the rest of the painting and decided on a mix of ultramarine and raw sienna, plus white for the field, and ultramarine and cadmium red for the foreground hedge.

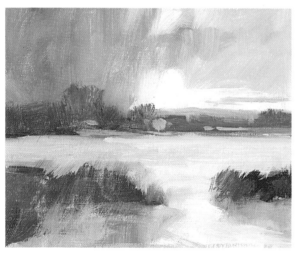

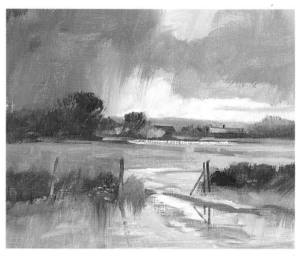

STEP THREE

With the mood and atmosphere beginning to emerge, I could concentrate more on the effect of rainfall. For this I mixed ultramarine, burnt umber and some raw sienna with white. For the distant sunlit sky I used raw sienna and a generous amount of white.

STEP FOUR

In the distance on the right, I picked out a rooftop-like shape, so I painted it in with cadmium red, raw sienna and white. Raw sienna and white were mixed for the lighter middle-distance trees. To complete the sky I added white and raw sienna for the brighter areas, then painted in a rainfilled track, posts and reflections. When dry, I finally scratched out the sun and highlights with a blade.

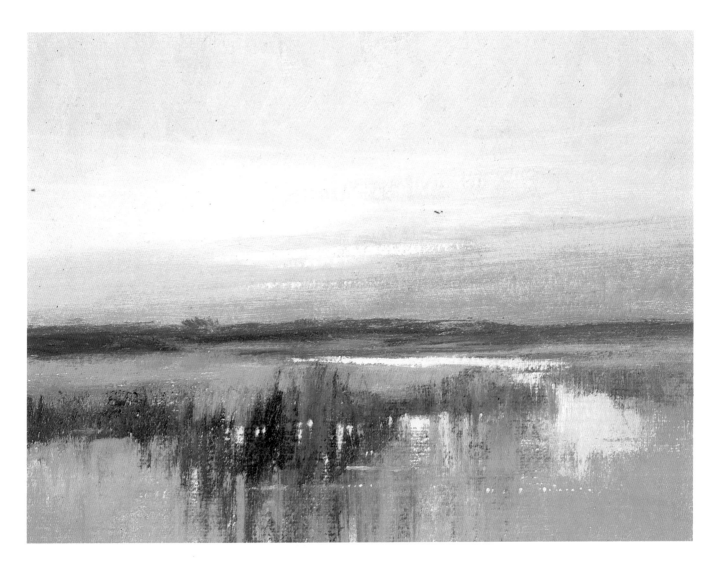

EVENING SKY, 51 x 41cm (20 x 16in)

The time of day when dusk begins to fall is a magical
moment. Capturing the mood and atmosphere of the
landscape in this light is a great challenge and success is
dependent on getting the tone values right.

 To achieve transparency in the sky I first of all applied
a thin mixture of raw sienna and white. While this was still
wet I brushed over a pale lilac colour, mixed from cobalt
blue and alizarin, and blended it into the underpainting
while it was still wet. Eliminating detail and simplifying
everything into big shapes is the way I approach subjects
similar to this painting.

 The colours used for this painting were raw sienna,
alizarin, cobalt blue, viridian, ultramarine and titanium white.

ENLARGING

A method of enlarging a sketch or photograph to the same proportion for a painting is by drawing a line from corner to corner as shown below. Instead of defacing a sketch or photograph, mark the lines on clear acetate or a tracing paper overlay. Small sheets of 20.5 x 31cm (8 x 12in) acetate can be obtained from stationery or art material suppliers.

Alternatively lay the original flat on the canvas or board and position a long ruler or wooden batten over it and mark off the diagonal. Squaring up the original with the same number of enlarged squares on the canvas or panel is an accurate way of enlarging an image. Some artists prefer using a photocopier for enlarging – they then trace off the image and transfer it to the painting surface.

BROOK, 38 x 28cm (15 x 11in)

(Right) This studio painting is on linen canvas and I have left the white priming untouched to suggest the sunlit areas of the clouds. For the sky I used cobalt blue, and for the clouds a tint of the same blue with a little alizarin. For the meadows, the base colour was raw sienna overpainted with cadmium yellow pale and ultramarine. The dark middle-distance trees were a mixture of ultramarine and alizarin. Counterchange of light against dark and dark against light creates interest and also the effect of recession by leading from one plane to another as they recede into the distance.

My colours were cobalt blue, alizarin, raw sienna, cadmium yellow pale, viridian and titanium white.

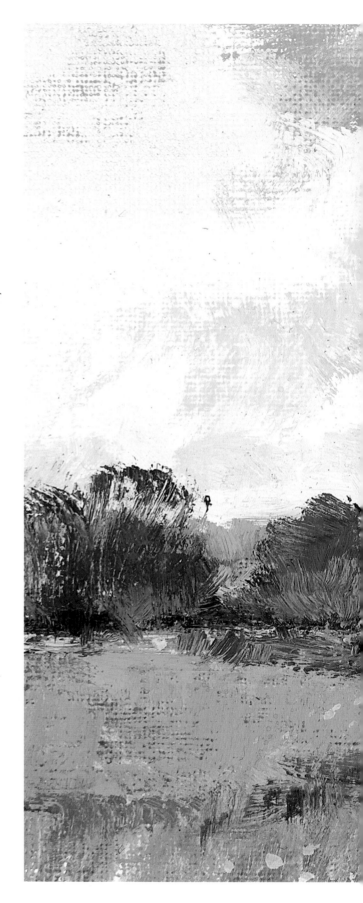

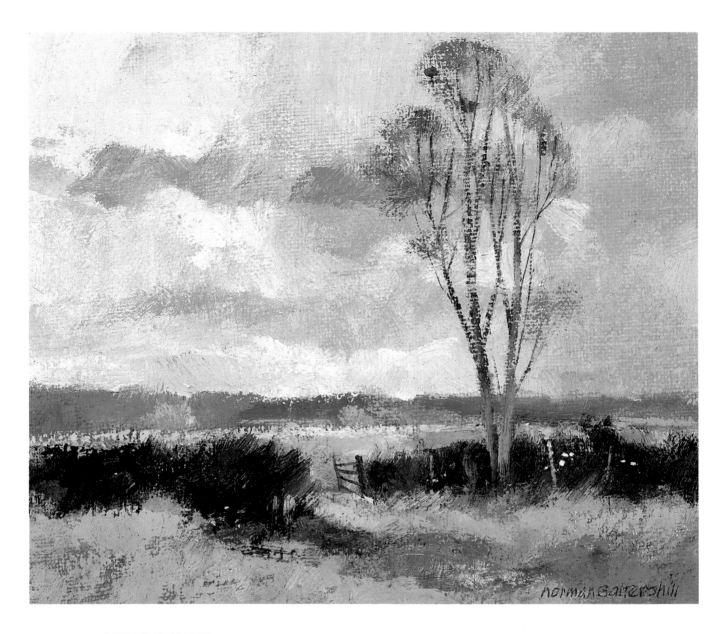

DORSET MEADOWS, 60 x 41cm (20 x 16in)

A very simple composition of horizontals and a strong
vertical form this studio painting. It is based on a sketch
of the fields by the River Stour where I often paint. For the
grey clouds I used burnt umber and ultramarine, also raw
sienna, alizarin and cobalt blue. I think the hedge is too
dark and would look better with an element of green in it.

My colours were ultramarine, alizarin, raw sienna,
cobalt blue, burnt sienna, burnt umber and titanium white.

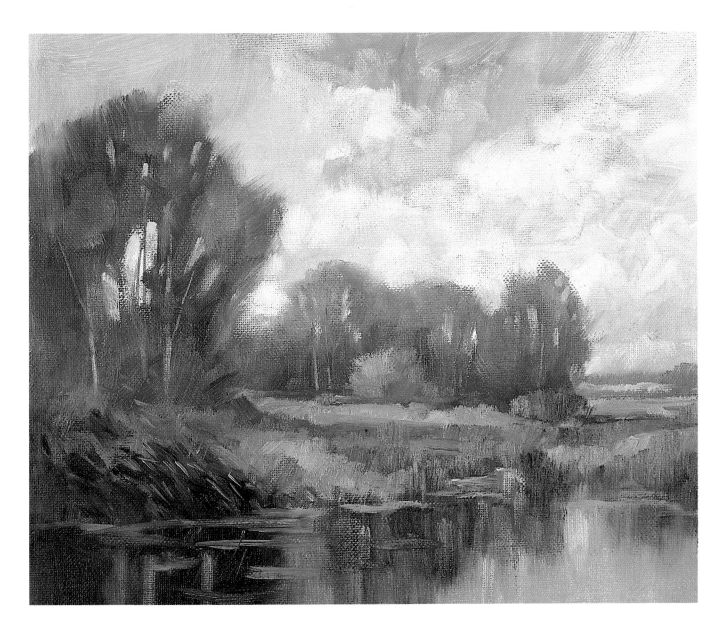

REFLECTIONS, 38 x 31cm (15 x 12in)

Here my favourite subjects are illustrated once again – water, trees and sky. For this painting I worked on an acrylic-primed linen panel. I roughed in the sky first to determine the pattern of clouds and lifted out sunlit parts with a clean turpsy rag. This is an effective technique for establishing accents of light at an early stage in the painting. All the principal dark tones were painted in next so I could start to build up colour.

While painting it is essential to keep in mind the kind of effect you wish to achieve. Here, it was the atmosphere of morning light and still reflections. The colours I used were ultramarine, cadmium red, alizarin, raw sienna, viridian and titanium white.

MORNING MIST, 30.5 x 25cm (12 x 10in)

The subject for this studio painting is imaginary. To achieve an effect of diffused light I simplified everything into big shapes and excluded detail. Cloud shapes were wiped out with a clean turpsy rag and left untouched. This had the effect of adding transparency and light to the sky.

Keeping colours fresh was important so I mixed as few as possible and endeavoured to get the tone values right first time.

The limited range of colours I used were ultramarine, raw sienna, viridian, alizarin and titanium white.

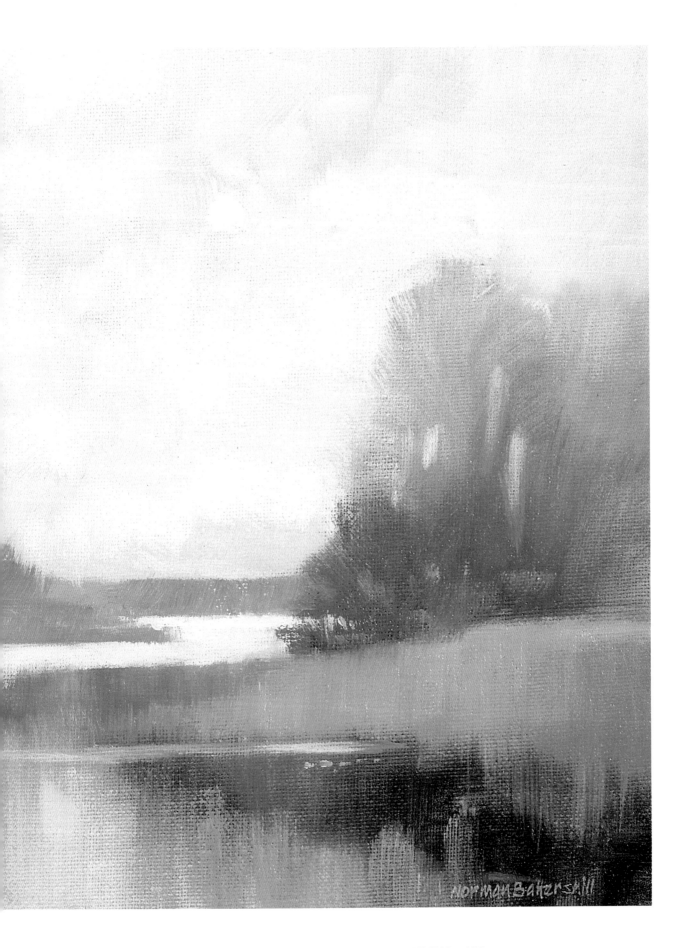

Gallery

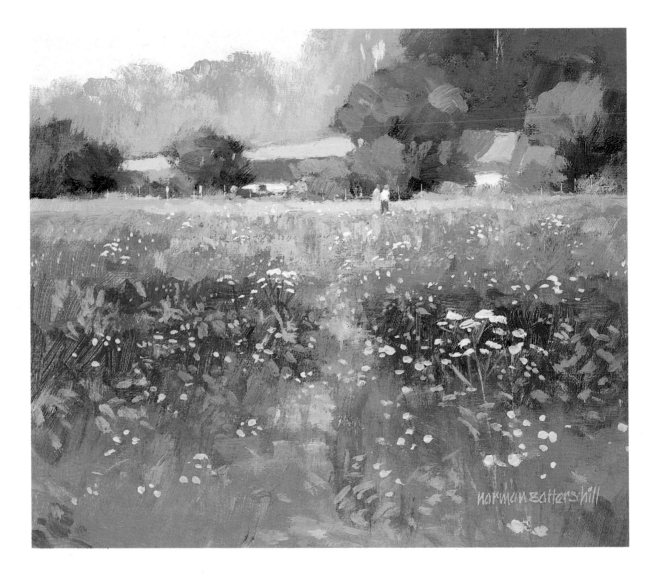

SUMMER FIELDS, 41 x 12cm (16 x 12in)

A sunny day in Dorset meadows provided the theme for this painting. The colours were raw sienna, viridian, cadmium yellow pale, burnt sienna, ultramarine, cadmium red and titanium white. What could be a more exciting subject than a field of wild flowers?

(Reproduced by kind permission of Wendy Robson.)

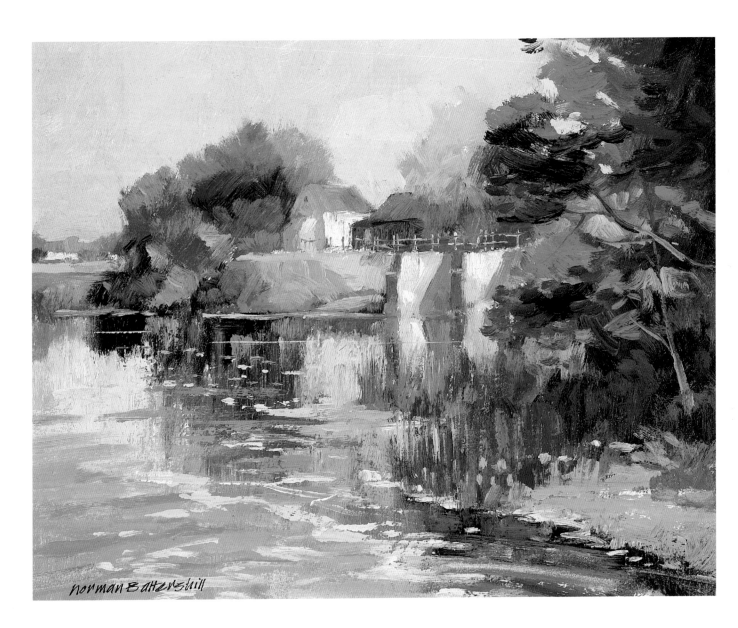

FIDDLEFORD MILL, 60 x 38cm (20 x 15in)

The contrast of calm and flowing water from the weir, and bright sunshine and rich summer foliage made this scene a wonderful subject. All the principal elements of landscape are featured in this tranquil setting.

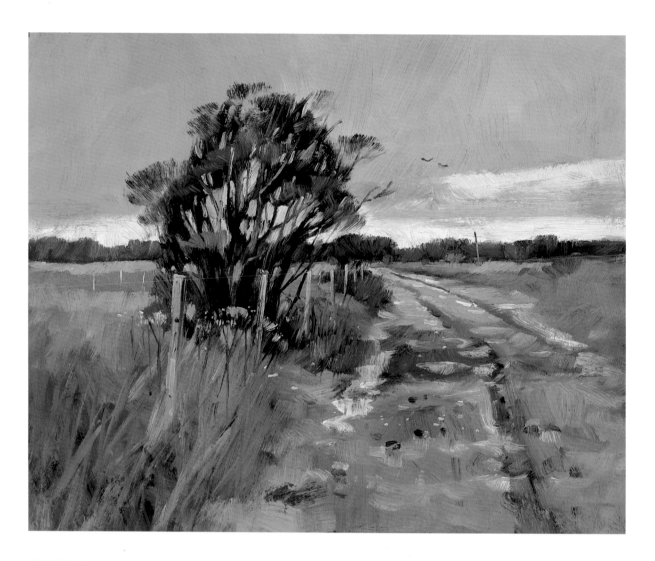

PASSING RAIN, 46 x 35.5cm (18 x 14in)

The rain-filled track is the main feature of this scene but the sky is the principal keynote. The contrast of brushwork between the sky and landscape adds to the mood of this winter painting. Scumbling is the technique of applying dry paint that is opaque or semi-transparent over a coloured ground. I have used this method in the sky of my painting to create luminosity. The texture of brushmarks and the underneath colour showing through enhance this effect.

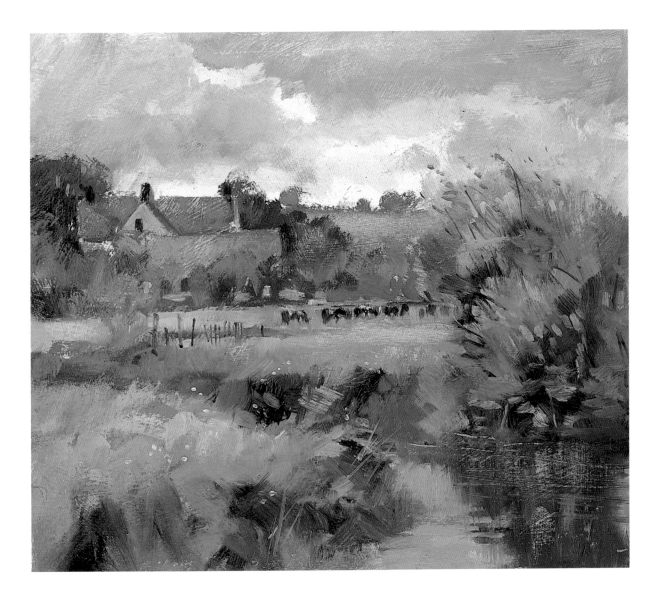

DORSET STREAM, 25.5 x 20.5cm (10 x 8in)

This outdoor painting is an example of an intimate corner of landscape which might very easily have been overlooked as a subject of interest. Low tone values determined by the quality of light from the sky contribute to the sense of time and place.

FIDDLEFORD, DORSET, 25.5 x 20.5cm (10 x 8in)

Autumn colours and a composition of big shapes attracted
me to this subject. The colours I used for this outdoor
painting were burnt sienna, cadmium red, ultramarine, raw
sienna and titanium white.

KINGCUPS ON THE STOUR, 20.5 x 18cm (8 x 7in)

A cluster of beautiful kingcups on the banks of the River
Stour was enough to inspire my painting here.

 (Reproduced by kind permission of Leslie and Joyce
Gaskell.)

Conclusion

Landscape painting is not just about making a faithful recording of what you see but the personal expression of how you feel about and respond to a subject. A great deal of emphasis is given to working direct from nature, however most of the greatest landscapes have been painted indoors. The artist's success is the result of technical ability, a knowledge of the broader elements and moods of nature, plus a receptive visual memory. The process of landscape painting begins outdoors and lasts a lifetime, with so much pleasure as a rich reward.

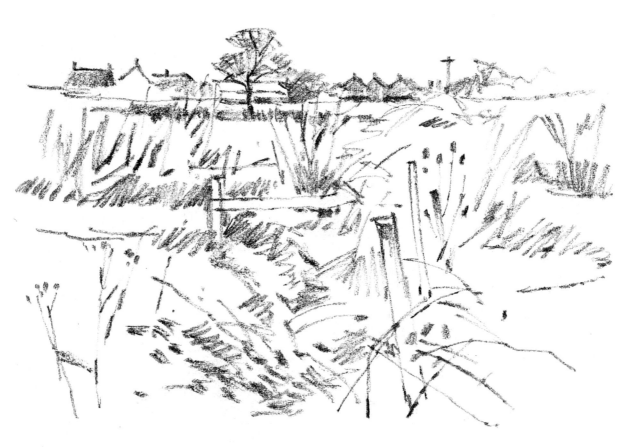

Biography

Norman Battershill is a member of the Royal Society of British Artists, a member of the Royal Institute of Oil Painters and Member of the Pastel Society. During his earlier career as a qualified designer with his own private practice in Knightsbridge, London, he was elected Fellow of the Society of Industrial Artists and Designers.

At this time his commissions included drawings for Post Office stamp books, line and wash drawings for Newsweek International, and paintings for the Post Office, CIBA-GEIGY and the Beecham Group.

Norman Battershill eventually decided to move from London to Sussex to be able to paint full-time. Soon after, he was appointed tutor for the Pitman Correspondence Course in Pastel and also elected a member of the demonstrator team for Winsor & Newton. He featured in their film *Painting with Acrylics* and his work was shown on Southern Television. Some of his commissions included landscape paintings for British Gas Southern. Many of his paintings are in private collections in the UK and abroad.

Norman Battershill is one of the members of the Royal Institute of Oil Painters to receive the Stanley Grimm award. He writes regularly for the *Leisure Painter* magazine and is author of more than a dozen art-instruction books.

His popular painting courses were always fully booked a year in advance but commitment to writing and painting now leaves very little spare time for teaching.

Norman Battershill now lives in rural Dorset in the heart of the Blackmore Vale.

Index